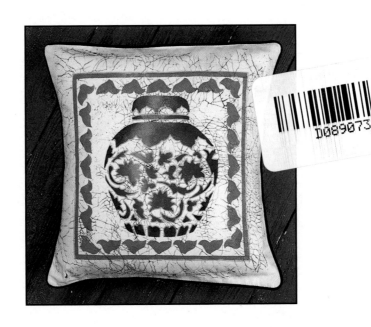

FABRIC PAINTING
MADE EASY

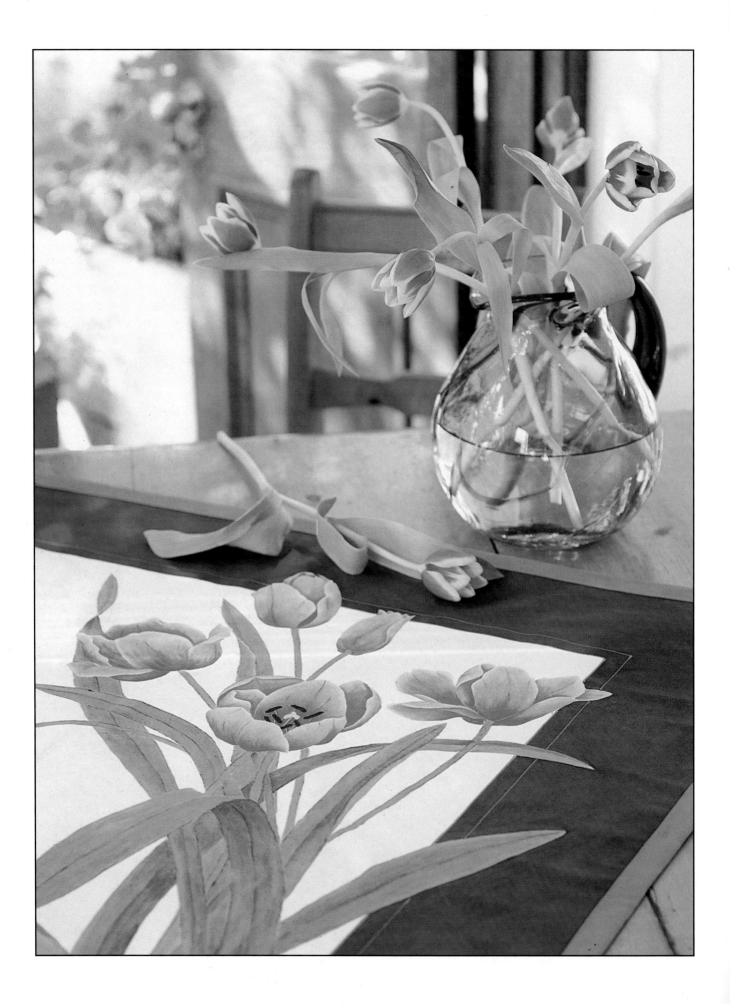

FABRIC PAINTING
MADE EASY

GRETHA LOUW

Human & Rousseau
Cape Town Pretoria Johannesburg

Acknowledgements

I have not followed any order of importance in thanking those who helped me with the creation of this book as everyone played a major role. However, I would like to start with my parents who gave me my first paintbrushes and fabric! And, Dad, the translation is even better than the original.

E B and children, thank you for your inspiration.

To Kevin O'Sullivan of K V Art, many thanks for the generous supply of all the paints I used.

Lastly, Issie, thank you for showing me everything new – you are a great teacher!

Tablecloth with painted flowers on page ii: Bold, bright colours combine with softer shades to highlight the tulips and make them focal points. Soft green and turquoise have been used to create a contrast with the tulips, and bronze liner to frame the picture. The tulip design appears at the back of the book.

Pictures on pages 10, 15, 18, 21 and 23 were sponsored by KV Art and Screenprinting Supplies.

First impression 1999
Second impression 1999

Copyright © 1999 by Gretha Louw
Published by Human & Rousseau (Pty) Ltd
Design Centre, 179 Loop Street, Cape Town
Photography by Neil Corder
Styling by Eileen Snowball
Picture on page 10 by Joseph Inns
Typography and cover design by Susan Theron
Text electronically prepared and set in 12 pt on 15pt Futura
by ALINEA STUDIO, Cape Town
Colour separation by Virtual Colour, Paarl
Printed and bound by Colorcraft, Hong Kong

ISBN 0 7981 3945 5

Contents

Preface

There is currently a tremendous interest in fabric painting in South Africa. I suspect this is because people enjoy decorating their homes themselves, especially now that such a colourful, easy-to-create-with medium has become available.

The materials required can be obtained throughout the country, the techniques are easy to master, and it is great fun – you have the satisfaction of producing instant results. I am sure almost anyone keen on fabric painting will become hooked merely by making a start and following the instructions in this book!

Fabric Painting Made Easy has been written for beginners and I have therefore approached the subject of fabric painting as a craft and not an art form. The basics are explained in simple terms and the instructions are clearly set out so that anyone can follow them and develop their own artistic style.

Over the past few years I have given a number of short courses in fabric painting. Most people have no difficulty applying the paint to the fabric, but drawing seems to be a stumbling block for many would-be painters. For this reason I have included a large number of designs for beginners to choose from. The mixing and combining of colours in pleasing designs also require some know-how and I have therefore covered both these aspects in detail.

I hope that this book will guide and inspire you – and that you will have a lot of fun!

Gretha Louw

Gretha Louw
17 March 1999

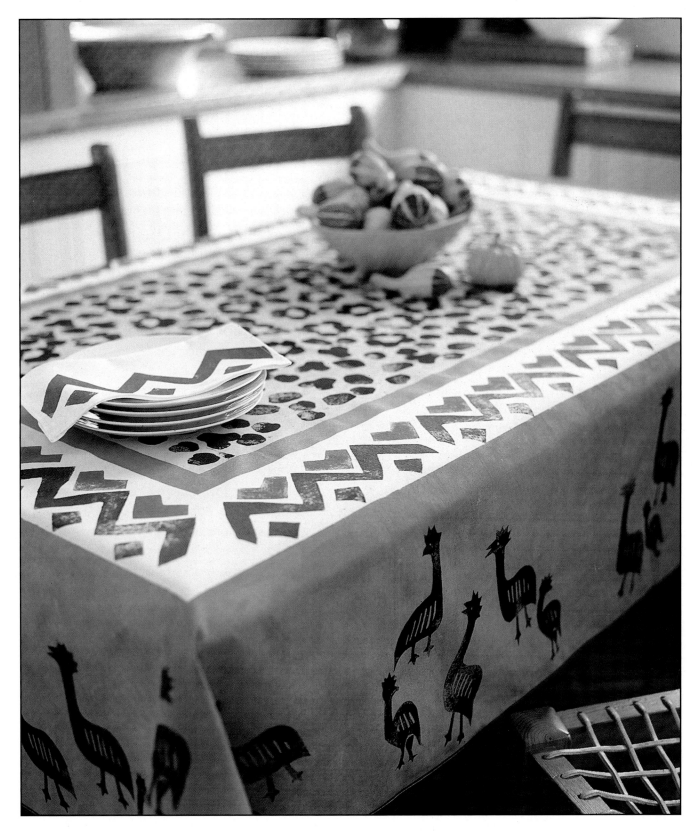

A few simple stamps enable you to achieve a striking effect in a short time. Various shapes and sizes of stamps (cut from synthetic leather) were used to create the "leopard spot" inside panel. The neat, straight line around this panel was painted by using strips of masking tape. Different groupings of birds (the designs appear at the back of the book) make the tablecloth more interesting. The serviettes were kept simple, with the colours of the border pattern reversed on the two edges.

Handy hints

Fabric paint can be used to decorate a wide range of articles, big or small, giving them a completely new look. Hints and practical advice appear throughout the book, but here are some additional hints which you may find helpful:

◊ Correcting painting mistakes by washing is not easy, even if the paints are not yet fixed. And, of course, once the paints are fixed, it is impossible! It is therefore very important to plan the design with the finished article in mind. Decide exactly where it should be placed on the article and choose the colours you want to use. Most importantly, draw the design and paint the fabric before cutting it to measure.

◊ Start with small projects such as placemats, tray-cloths and scatter cushions, and progressively move to bigger projects such as tablecloths, curtains and duvet covers.

◊ Be adventurous! Once you have mastered a few techniques, you should try combining them – the effect can be stunning.

◊ Use bleach to remove marks from soiled articles; if the paint is fixed it will not be affected.

◊ Draw any straight lines in your design with a bevelled ruler placed upside down. This will prevent the paint from running underneath the ruler and smudging the fabric.

◊ Hand wash articles in cold or hot water. Use detergent or soft soap, taking care not to rub or wring the article as this will spoil the fixed paint. Articles can be dried in sunlight, and remember to hang them while soaking wet.

◊ To prevent damaging the painted fabric, articles should always be ironed on the reverse side. If this is impossible cover the painted areas with a piece of cloth to protect them while ironing.

Painting on T-shirts

1. From a piece of stiff cardboard, cut an insert for the T-shirt large enough to strech the fabric of the shirt slightly taut. This will facilitate the application of the paint and also prevent the paint from seeping through the fabric.
2. Place the design between the shirt and cardboard and trace it onto the fabric using a nonpermanent felt-tip pen.
3. Apply the paints, taking care to secure the fabric so that it does not stretch.
4. Once the paint has dried completely, iron the shirt on the wrong side to fix the design.
5. It is preferable to use pure cotton T-shirts only. Other fabrics may cause the paint to run along the edges.
6. Fabric markers are useful for drawing in the outlines of the design, but bear in mind that the marks tend to fade eventually.

Painting on dark fabrics

Ordinary fabric paint is not suitable for dark fabrics, as it is transparent.

Opaque paints, however, produce excellent results. Likewise, metallic paints are suitable for use on dark fabrics. Apart from the popular gold, bronze and silver paints, other pearl-based colours are most effective for certain designs.

Remember, metallic and pearl-based paints should always be ironed on the **wrong** side!

A few simple elements were added to the frog design at the back of the book to create a fun T-shirt for a special boy (you will find lots of ideas for children's clothes in colouring books). Different shades of blue create a more interesting water effect; the veins on the leaf were made with the sgraffito technique (page 28).

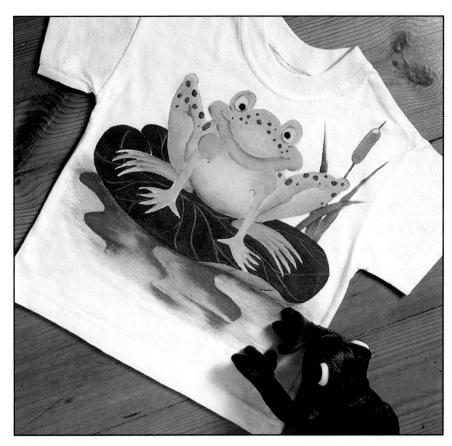

Metallic paints add sparkle and give life to dull, dark fabrics. Gold liner was used for this simple but striking African mask design – you will find it at the back of the book. Use white chalk to draw the design onto dark fabric.

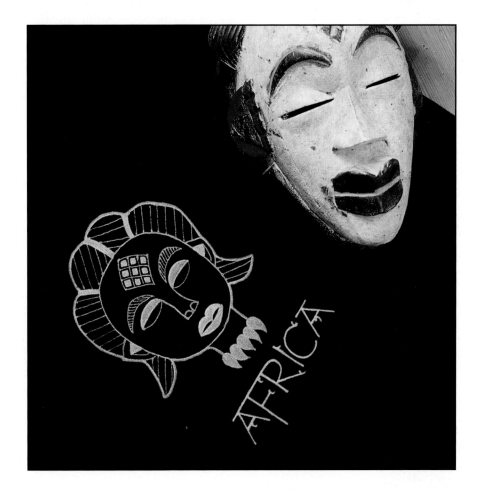

Basic requirements

Do not be intimidated by all the paints, paint-brushes and other materials at your local art shop. Simply start with the basics mentioned here. Once you have mastered a technique that appeals to you, you can experiment with additional products and materials to achieve special effects.

Fabrics

The final product that you have in mind will determine your choice of fabric, but always use 100% cotton. It is advisable to wash the fabric before you start painting.

Calico is the most suitable fabric for painting because of its weave: the tighter the weave, the better the end result. I use a high-grade, unbleached calico that is preshrunk and prepared for printing. One drawback, though, is that it is only 150 cm wide.

It is wise to practise on inexpensive bleached or unbleached cotton beforehand. Once you have mastered the various techniques and have gained some confidence, you can use the best available fabric so that the article remains attractive for as long as possible.

Paint

Fabric paints are water-based and easy to use.

Once the design is complete, the fabric must be ironed on the wrong side to fix the colours. Use a very hot iron (cotton setting) and iron for three minutes. The painted fabric can now be washed and ironed without any fear of the colours fading. (See the washing instructions on page 8; it is also important to always read the fixing instructions of the paint you are using.)

Art shops sell a wide variety of fabric paints at different prices. Apart from the ordinary transparent and pearl-based colours you can also choose from neon, metallic or opaque paints. Metallic and opaque fabric paints are especially useful if you have to overpaint small sections of a picture.

The colour range is enormous but do not get confused: initially you will only need a few basic colours. I find it quite adequate to use the three primary colours – red, blue and yellow – plus ochre and navy, and plenty of extender. The extender is essential for lightening colours. You will use large quantities of it, so to start with buy one litre! I also use liners to give designs a nice finish. The liners, available in many colours, come in small bottles with applicator nozzles.

With a bit of practice you will find that the most beautiful shades can be produced by mixing these basic colours. Do not be afraid to experiment! It is great fun and you will soon learn how to combine the various colours.

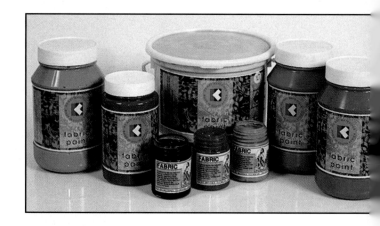

Fabric paints are available in different-sized containers.

Everything you need to start painting on fabric.

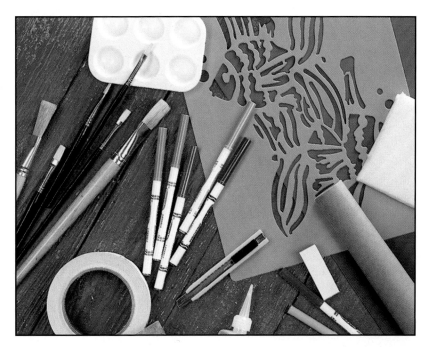

Paintbrushes

Do not buy the most expensive paintbrushes. Rather buy a good selection of the more inexpensive ones.

I prefer flat paintbrushes made of pig bristle. Invest in two no 2 paintbrushes for fine work, two no 6 or no 8 paintbrushes for general painting, and one no 20 paintbrush for covering large areas. Flat paintbrushes allow you more control, especially when painting along lines and painting detail.

Accessories

The fabric, paints and paintbrushes are the essentials, but the following accessories will also come in handy:
◊ I do my painting on a table covered with several layers of plain newspaper, obtainable from a local printer. The paper protects the table and absorbs any paint that seeps through the fabric.
◊ Smaller pieces of fabric can be taped to a piece of hardboard to secure them while

painting and stored in a cupboard while you wait for the paint to dry. This is an excellent solution when you are short of space and also protects your unfinished work from small children and pets.
◊ Small, wide-mouthed jars for storing leftover mixed paints.
◊ A cloth for cleaning your hands.
◊ Wooden spatulas for mixing paints and to ensure better distribution of paints.
◊ A suitable basin for cleaning paintbrushes.
◊ Small pieces of foam rubber for sponging paint onto large areas.
◊ An HB pencil for drawing the designs and soft eraser to remove the pencil lines.
◊ Instead of a pencil use a nonpermanent felt-tip pen to draw the designs. The colours cannot be fixed and will wash out. Use colours that suit the design: green for leaves, yellow for a lemon, etc.
◊ You can also use a charcoal pencil for drawing the designs. The charcoal can be removed with a piece of adhesive tape.

This is all you need to start painting . . . Additional accessories for special techniques are listed with the particular techniques.

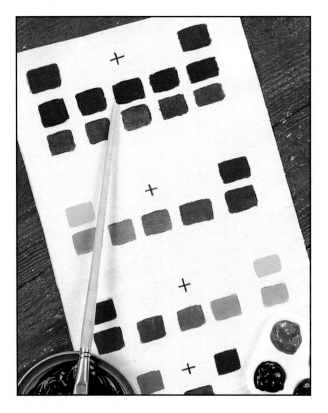

Keep your sample cloth handy when you want to mix new colours and use extender to obtain lighter shades. Always write down your recipe for a particular colour; it is a good idea to attach a painted sample cloth to the filed recipe for easy reference.

Mixing colours

The best way to start fabric painting is to familiarise yourself with mixing colours. Do this by making your own sample cloth. To start, paint a small square or strip with primary yellow paint. Next, mix small quantities of yellow with varying proportions of the other basic colours. Repeat this process with the other primary colours.

1 part yellow + ¼ part red
1 part yellow + ½ part red
1 part yellow + 1 part red

1 part yellow + ¼ part blue
1 part yellow + ½ part blue
1 part yellow + 1 part blue

1 part yellow + ¼ part navy
1 part yellow + ½ part navy
1 part yellow + 1 part navy

1 part yellow + 1 part ochre = sun-flower yellow

1 part red + ¼ part yellow
1 part red + ½ part yellow
1 part red + 1 part yellow

1 part red + ¼ part blue
1 part red + ½ part blue
1 part red + 1 part blue

1 part red + ⅛ part navy
1 part red + ¼ part navy
1 part red + ½ part navy
1 part red + 1 part navy

1 part red + 1 part ochre = cherry red

1 part blue + ¼ part yellow
1 part blue + ½ part yellow
1 part blue + 1 part yellow

1 part blue + ¼ part red

1 part blue + ½ part red
1 part blue + 1 part red

1 part blue + 1 part ochre = avocado green
1 part blue + 1 part navy = deep royal blue
1 part navy blue + 1 part ochre = dark greenish grey
1 part red + 1 part green = brown

Remember: the proportions given are mere guidelines; by varying the proportions slightly you will find that special shade you need for a particular application. Experiment until you find the exact colour you want.

Use extender to dilute the different colours and obtain beautiful lighter shades:
Pinks: by diluting a small amount of red lovely pinks are obtained.
Skin colour: dilute a little oxide (rust-coloured) with extender to obtain a soft pink. By adding a small amount of ochre a more natural skin colour is obtained. Remember to mix the colours well!

With the above combinations you are able to mix your own oranges, purples, greens, browns, etc. Do not forget to make a note of the proportions used and label the colours: cerise, sunflower yellow, etc. Create your own names if necessary. It can be lots of fun!

Useful hints

- Most beginners find it hard to judge how much paint to apply. The secret is to apply the paint quite liberally to cover your design, but check the back of the fabric: if the paint seeps through you are applying too much.
- Do not use too much water for diluting paints as it will cause the paint to run on the fabric and affect the colourfastness.
- Ochre tones down bright colours to produce subtle shades.
- Add navy to darken bright colours. Navy is useful for filling in shadows, but use it sparingly as it is highly concentrated.
- Keep colour intensity in mind when choosing the colours for a particular design. Decide when to use lighter, paler shades and when to use darker, more saturated colours.
- Use contrast in your design to make it more interesting. Use yellow against dark blue or lighter objects next to darker ones: place purple grapes among light green foliage, for instance.
- Wash the paintbrushes well to prevent the bristles from hardening and sticking together.
- Keep the lids of paint jars tightly screwed on when not in use. Once the paint has dried, it is useless.
- Whatever paint technique you use, allow the paint to dry completely before ironing the fabric on the wrong side with a very hot iron (cotton setting) for 3 minutes.

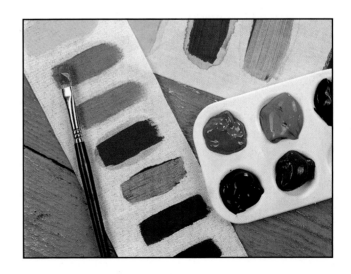

Before you buy or use a piece of fabric, it is important to experiment on a small piece to make sure that bleeding will not occur. Always paint a few strips as shown here and wait a while to see the effect.

Techniques

The materials required for each technique are listed here. Where possible the degree of difficulty has also been indicated.

Prints

(Very easy)

Print techniques are very fast and particularly useful for keeping children occupied painting their T-shirts, for instance. (See painting on T-shirts on page 8.)

You will need:

◊ Paint
◊ Paintbrushes
◊ Used X-ray plates (or acetate sheets, available from art suppliers), *or*
◊ Leaves, bottle corks, etc., *or*
◊ Rubber stamps
◊ Fabric
◊ Foam-rubber sponges
◊ Spatulas
◊ Iron

Keep the design as simple as possible and avoid painting too many colours on X-ray plates — the colours will mix and blot, and result in a messy look.

X-ray plate technique

(Very easy)

This method results in a mirror image of your design, therefore words must be written back to front. There are two ways of using the plates:

Method 1

1. Apply paint evenly to the entire X-ray plate, then, using your finger or the back of a paintbrush, draw the design in the paint while still wet.
2. Place the prepared X-ray plate face down on the fabric and press down lightly.
3. Carefully lift the X-ray plate, taking care not to smudge the paint.
4. Leave to dry thoroughly.

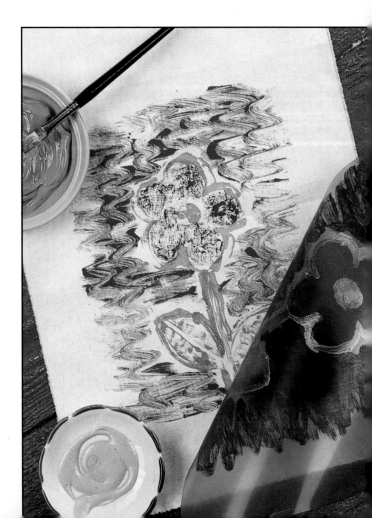

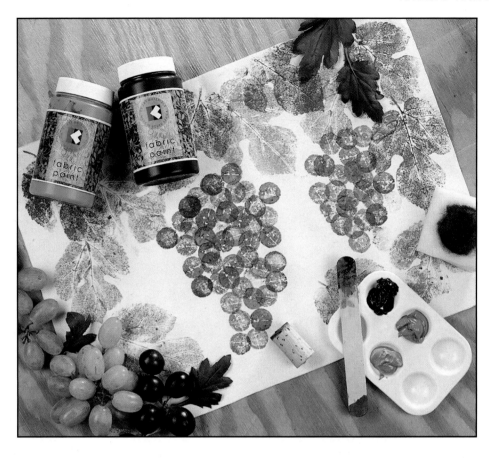

Different colours printed with a cork give depth to the design and result in a more interesting bunch of grapes; here the available leaves were the wrong shape and were cut to fit the design. If the prints are light, it is best to leave the background unpainted. Always take care not to use too much paint when printing with objects, because this can result in a messy outline.

Method 2

1. Draw your design on the X-ray plate using a paintbrush and paints. More than one colour may be used.
2. Place the prepared X-ray plate face down on the fabric, press down lightly, then re-move carefully.
3. Leave to dry thoroughly.

For both methods: iron the fabric on the wrong side with a very hot iron (cotton set-ting) to fix the paints.

Prints of objects

(Very easy)

Leaves, bottle corks, potato cutouts and rubber stamps are ideal for printing designs, but keep an eye out for any other objects suitable for making interesting prints.

Hint

• Use a small sponge to dab the paint onto the stamp.

Leaves

1. Either side of a leave may be used, but the back accentuates the veins better than the front.
2. Sponge the paint evenly over the preferred side of the leaf.
3. Place the leaf on the fabric and press down lightly, using a dry cloth to protect the leaf.
4. Remove the leaf carefully.
5. Repeat the process as desired, using the same leaf with or without others.
6. Leave the fabric to dry completely before ironing on the wrong side with a very hot iron (cotton setting).

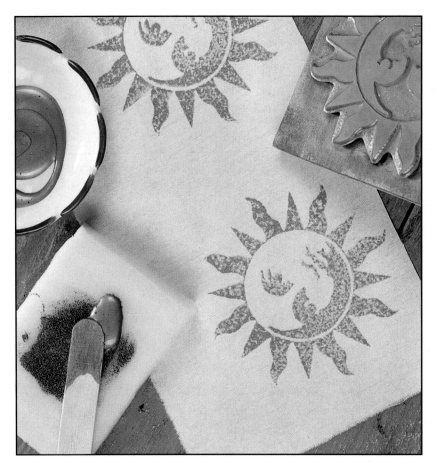

Be careful when you work with stamps, because it is almost impossible to rectify mistakes. Lightly mark the position of stamps with a nonpermanent felt-tip pen. Remember that this technique results in light (and not concentrated) colours.

Rubber stamps

(Easy)

Ready-made stamps may be used, but bear in mind that the less complicated stamps make the best designs. Home-made stamps are easy to make and provide more scope for using your imagination. All you need are small blocks of wood, adhesive and different shapes cut from cork, foam rubber or plastic floor covering. Even bits of string glued to the stamp surface make interesting textured designs. Children's toys, such as the foam-rubber toys they use for playing in the bath, are perfect for creating special effects.

Hint

• Remember to use water-resistant adhesive when making your stamps.

1. Apply enough paint onto a foam-rubber sponge and use a wooden spatula to spread the paint evenly into it. The sponge serves as a stamp pad.
2. Dab the stamp a few times on the foam-rubber sponge to spread the paint evenly over its surface.
3. Carefully place the stamp on the fabric in the desired position and press down lightly.
4. Remove the stamp and repeat the process.
5. Leave the fabric to dry completely before ironing on the wrong side with a very hot iron (cotton setting).

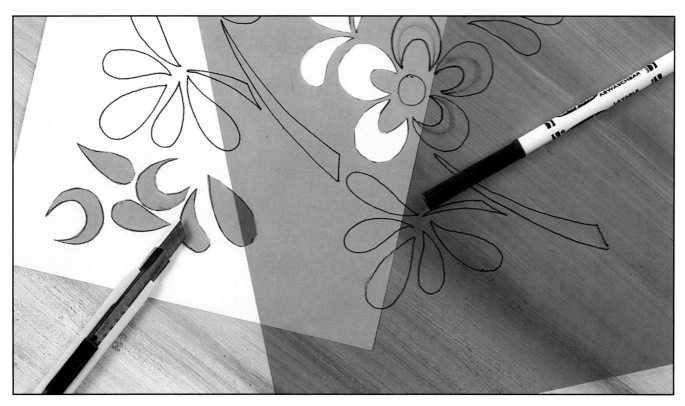

Stencilling

(Easy)

You will need:

◊ Old X-ray plates, stencil paper, cardboard or acetate sheets for making your own stencils
◊ Pencil or nonpermanent felt-tip pen
◊ Craft knife or scissors
◊ Cutting board
◊ Cloth
◊ Masking tape
◊ Stencil paintbrushes or foam-rubber sponges
◊ Shallow dish
◊ Paint
◊ Iron

This is a fast technique which can be repeated a number of times to create a design. Stencils may be bought at art or stationery shops or you can cut your own from X-ray plates, laminated craft or any other suitable board.

A wide border around the cut-out stencil will protect the fabric during the painting process. To get a neat stencil, you need to use a sharp craft knife.

Cutting your own stencils

1. Select a simple design and place it underneath the X-ray plate.
2. Draw the design on the plate using a broad nonpermanent felt-tip pen, taking care that all the lines join up.
3. Working on a cutting board, cut out the design on the inside of the black line with a craft knife.
4. Make sure the lines are not too thin as they are liable to break.
5. Carefully wipe the stencil with a damp cloth to remove the pen marks before use.

Plastic stencils

1. Secure the stencil to the fabric with masking tape.
2. Use either a stencil paintbrush or small sponge to apply the paint.
3. Pour a little paint into a shallow dish, then dip the paintbrush or sponge in the paint, taking care not to pick up too much paint as this could cause unsightly blotches or the paint to run on the fabric. Rub the paint into the sponge with a spatula.
4. Lightly tamp the paint onto the design with the paintbrush or sponge, repeating the process until the paint is spread evenly. Take your time, shading the paint into the fabric.

Hint

- Tie the corners of the sponge together with a piece of string or adhesive tape to form a round pad. This will improve your control of the sponge and will result in a more even application of the paint.

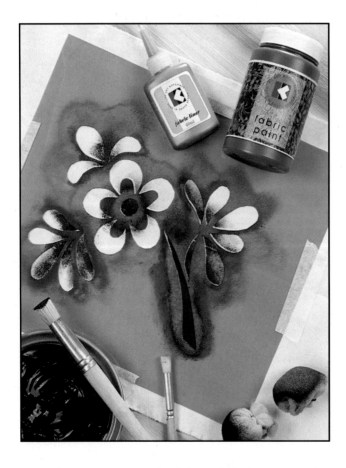

Use a clean sponge or paintbrush for each shade to ensure that the colour remains clean and sharp. It is also important to first apply one shade before you progress to the next. You can reverse the stencil for a mirror image.

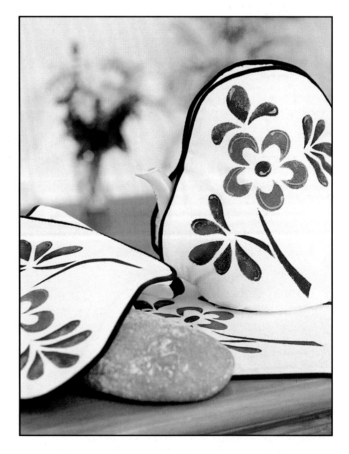

Use different shades of a colour to give life and dimension to stencilwork, and add bronze liner for a finished look. This design is at the back of the book.

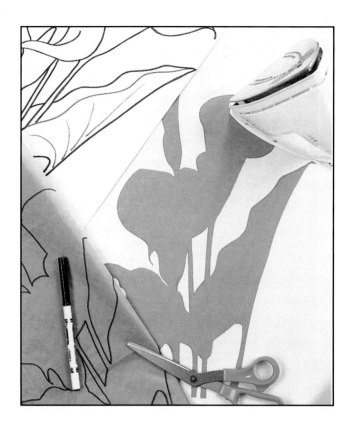

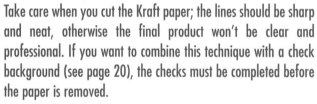

Take care when you cut the Kraft paper; the lines should be sharp and neat, otherwise the final product won't be clear and professional. If you want to combine this technique with a check background (see page 20), the checks must be completed before the paper is removed.

An even background was obtained by tamping with a paintbrush. The design appears at the back of the book, and a picture of the finished article on page 30.

Kraft stencils

Use laminted Kraft paper (brown paper plastic-coated on one side). This type of stencilling takes longer but allows for more detail.

1. Draw the design on the fabric with a pencil or nonpermanent felt-tip pen.
2. Draw the design on the unlaminated side of the Kraft paper with a sharp pencil.
3. Cut out the design with a pair of scissors. You will now have two parts: the design and the background.
4. Iron the design onto the fabric (laminated side facing the fabric) using a medium-hot iron. Take care that the iron is not too hot, as the laminated backing of the Kraft paper will melt into the fabric.
5. Paint the background in a contrasting colour. Apply the paint from the paper to the fabric.
6. Leave the paint to dry completely.
7. Peel the stencil from the fabric, taking care not to tear the paper so that it may be used again.
8. Iron the fabric on the wrong side with a very hot iron (cotton setting).
9. Fix the background stencil to the fabric using a medium-hot iron.
10. Paint the design and leave to dry completely.
11. Carefully peel the stencil from the fabric.
12. Paint in the detail.
13. Iron the fabric on the wrong side with a very hot iron (cotton setting).

Checks and stripes

(Easy)

This is a fast, effective technique and can easily be combined with other techniques – but be careful to plan ahead so that the whole design will be pleasing. Gingham checks, irregular checks, trelliswork and multicoloured checks are suitable for fabric painting.

You will need:

◊ Fabric
◊ Ruler
◊ Pencil
◊ Masking tape
◊ Paint
◊ Foam-rubber sponges or paintbrushes
◊ Iron

1. Mark the stripes on the fabric using a ruler and pencil.
2. Mask the areas on the fabric to be left unpainted with masking tape, taking care that the tape is properly fixed to the fabric.
3. Apply paint to the sponge or paintbrush. If using a sponge, work it in with a spatula to ensure better distribution of the paint.
4. Paint the unmasked areas. Remember to apply the paint in the same direction as the masking tape to prevent it from seeping under the tape.
5. Leave the paint to dry completely before carefully removing the masking tape. The tape may be used a number of times if care is taken not to crumple the tape.
6. Iron the fabric on the wrong side with a very hot iron (cotton setting).
7. For a check design repeat the process horizontally across the painted stripes.

Hints

- It is important to avoid colour combinations such as red and green, blue and orange, or purple and yellow – these will result in a brownish mixture where the stripes cross one another.
- If you limit the check design to one colour, use extender to lighten the paint. This will result in a more intense colour where the lines intersect.
- For an irregular check use two different widths of masking tape.

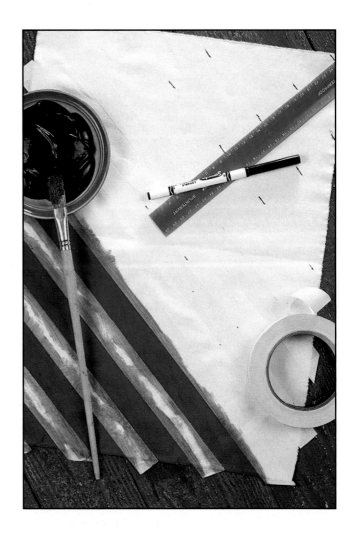

Make sure that you use a clean roll of masking tape; if dirty, the tape can spoil your design.

Combine a bronze liner with blue or green paint, or a silver liner with red paint, for an interesting variation. Remember to use a bevelled ruler placed upside down when you draw lines with a liner.

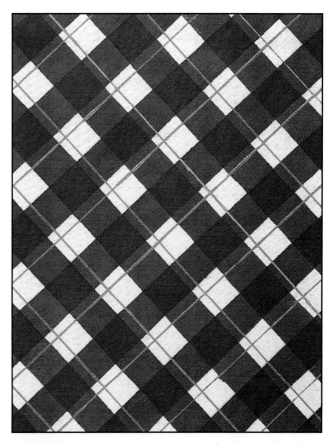

The lines need not cross at the same angles; experiment with different angles to create interesting effects.

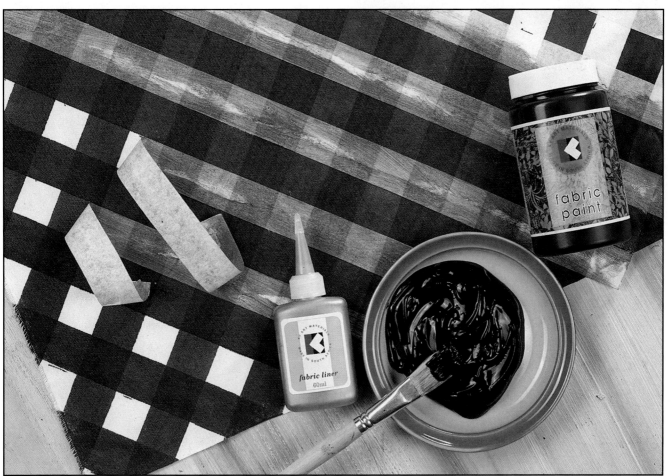

Batik

(Very easy)

An exciting technique which can be varied as desired. For best results use simple designs.

The flour paste is used to protect the un-painted areas of your design on the fabric. This enables you to keep the background, the design or the exterior lines unpainted. Combinations are also possible.

Recipe for flour paste

250 ml flour (use refined cake flour)
200 ml water
Mix well to remove any lumps.

Hint

• The flour paste tends to go sour when stored but it is still usable.

You will need:

◊ Fabric
◊ Pencil or nonpermanent felt-tip pen
◊ Flour paste
◊ Paintbrushes
◊ Paint
◊ Foam-rubber sponges
◊ Iron
◊ Plastic bag
◊ Applicator bottle for trimming

Batik trimming

Trimming is used to accentuate the outlines of the design, highlight some feature of the design, or to fill in design details such as stamens, veins of leaves, thin stalks, etc.

1. Select your design and draw it on the fabric using a pencil or water-based felt-tip pen.
2. Cover all the design lines with the flour paste, ensuring that all the lines join up.
3. Leave the flour paste to dry completely.
4. Paint in the design and background as desired.

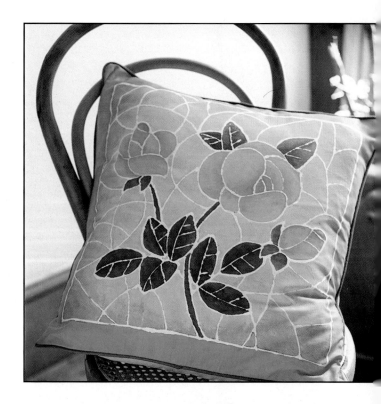

This colourful cushion for a sun room (design at the back), shows the crisp and neat look that you can obtain with the batik trimming technique. It is important to use a slender-tipped nozzle for fine lines.

5. Fill in detail using scratchwork or shading. (For an explanation of these techniques see freehand painting on pages 25-28.)
6. Leave the paint to dry completely.
7. Fix the paint by ironing on the wrong side of the fabric with a very hot iron (cotton setting).
8. Soak the fabric in water and rub gently with a sponge to remove the flour paste.
9. Leave the fabric to dry completely and iron well.

Hint

• To transfer the flour paste to the applicator bottle, spoon a little of the mixture into a plastic bag, snip a corner off the bag and squeeze the paste into the bottle.

All the lines need not be of the same thickness. To draw an even line, it is best to keep the nozzle close to the fabric while pressing gently on the applicator bottle. Don't get worried if the dried flour paste starts to crack – in this way you will get more texture.

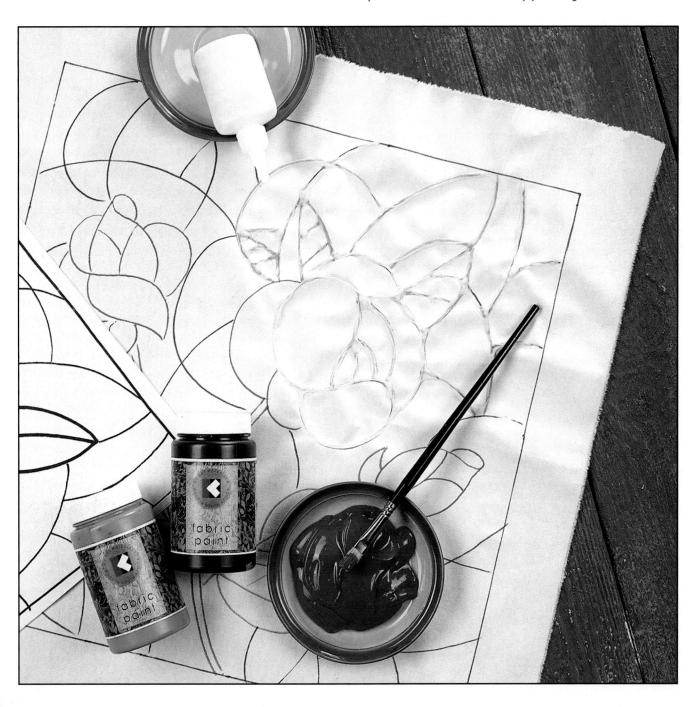

Technique for cracked look

(background or design)

1. Draw your design on the fabric using a pencil or nonpermanent felt-tip pen.
2. Cover the area where cracks are required with the flour paste, applying it with a wide paintbrush or spatula.
3. Leave to dry. The fabric will become lumpy as the flour paste dries and shrinks.
4. Crumple the fabric but do not rub.
5. Apply a dark colour over the areas covered with the flour paste using a sponge or paintbrush. Ensure that the fabric paint penetrates the cracks in the flour paste.
6. Leave to dry well and fix the paint by ironing the fabric on the wrong side with a very hot iron (cotton setting).
7. Soak the fabric in water and rub gently with a sponge to remove the softened flour paste.
8. Allow the fabric to dry completely and iron.

9. Paint in the detail as required, leave to dry and iron on the wrong side of the fabric with a very hot iron (cotton setting).

Hint

• Batik can be used over any paint technique to obtain an antique appearance, but first the previous work must be fixed by ironing the fabric on the wrong side with a very hot iron (cotton setting).

A simple design such as this ginger jar stencil (you will find the design at the back of the book, and a close-up picture on page i) is perfect to use on a cracked background. To achieve this particular effect the whole piece of fabric has to be evenly covered with the flour paste. An element from the ginger jar design was used to create a stencil for the frame (this stencil forms one side of the square). Different shades of blue add dimension and the gold liner gives a more finished look.

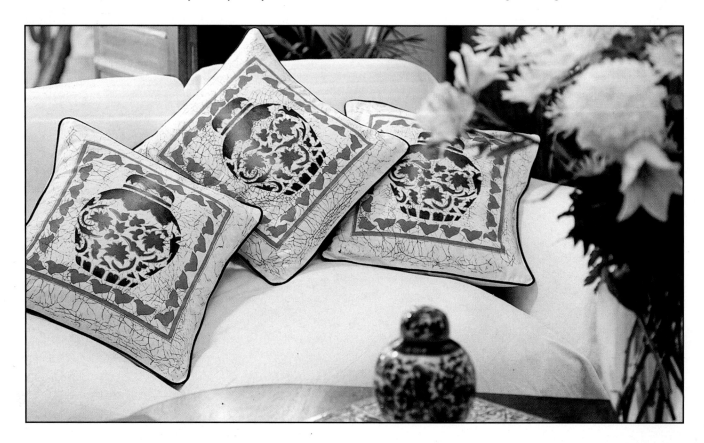

Freehand painting

Although this technique is more difficult than the preceding ones and requires better hand control, do not be daunted – it is more a technique than an art form. A few tricks will help you master it.

You will need:

◊ Pencil or nonpermanent felt-tip pen
◊ Paint
◊ Soft eraser
◊ Paintbrushes

Hint

• First draw the design on paper with a felt-tip pen and then trace it onto the fabric in pencil to eliminate any errors.

1. Trace the design onto the fabric in pencil.
2. Apply the paint, always starting with the lighter colours and proceeding to the darker hues. As the paint is transparent darker colours will be visible under lighter ones. Dark blue will be visible, for instance, if yellow is applied over it. Only opaque paints are not transparent.
3. Always start in the centre of a design and paint towards the outside. Hold the paintbrush so that the free end points to the outer edge of the design.
4. To obtain an even, light colour first apply extender to the area and then blend in the required colour.
5. To obtain an even, dark colour first paint the area in the usual way, then tamp the paint lightly onto the fabric with the paintbrush, ensuring that the sides of the bristles make contact with the fabric. Keep

this up until the paint is spread evenly.
6. To paint in shadows, apply a thin line of dark paint, then carefully blend it in by tamping with the paintbrush.
7. It is advisable to use a narrow paintbrush when painting in shadows so that you do not apply too much dark paint.
8. The best colours for shadows are purple and navy, but test these on a leftover piece of fabric before using them on your painting.
9. Highlights add sparkle to your painting. Use white or white pearl gloss paint.
10. Objects can be textured by scratching the wet paint with the back of a paintbrush, a comb or table fork.
11. The veins of leaves, background designs and borders can be drawn into the wet paint with the back of a paintbrush.
12. Metallic paints and opaques are useful for using on dark fabric or for painting on a dark background.

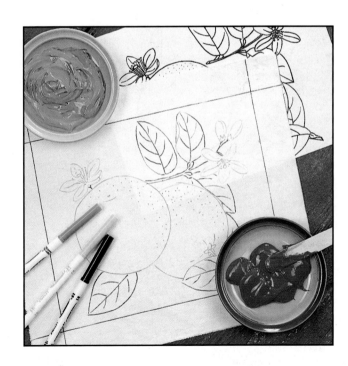

Choose an area with sufficient light to ensure that the design will show through the fabric. Otherwise it is best to fix both the design and piece of fabric to a windowpane to trace the design.

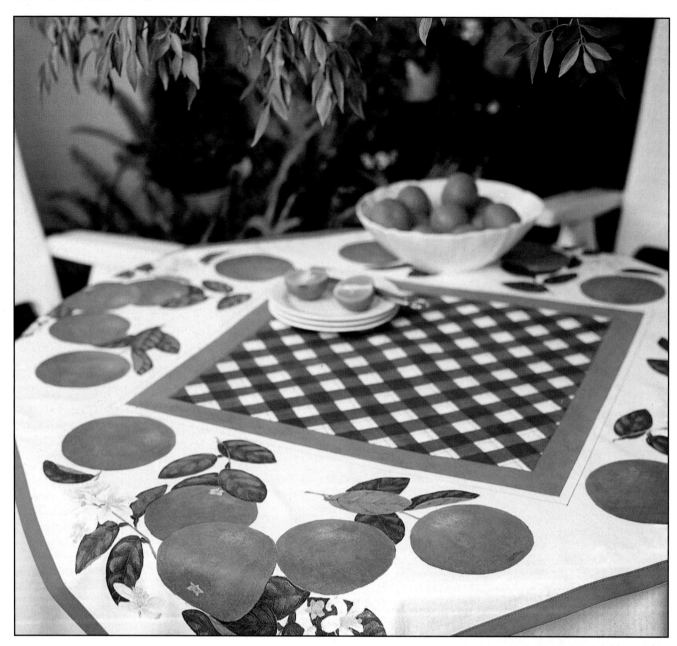

A bright and fruity breakfast tablecloth (designs for oranges and blossoms appear at the back, see page 20 for checks and stripes). White pearl gloss paint was used to add highlights to the design, and bronze liner to define the green checks as well as the centre panel. Paint leaves in different shades (mix a little white paint with the green) for a more interesting effect.

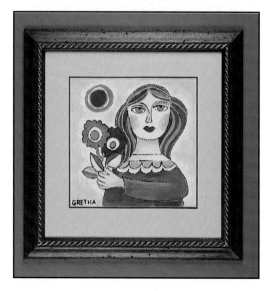

Bronze, black and gold liners accentuate the simplicity of this picture and give it a more finished look. You will find the design at the back of the book. To obtain the skin colour you have to use a lot of extender, a little bit of ochre and a little bit of oxide, mixed very well.

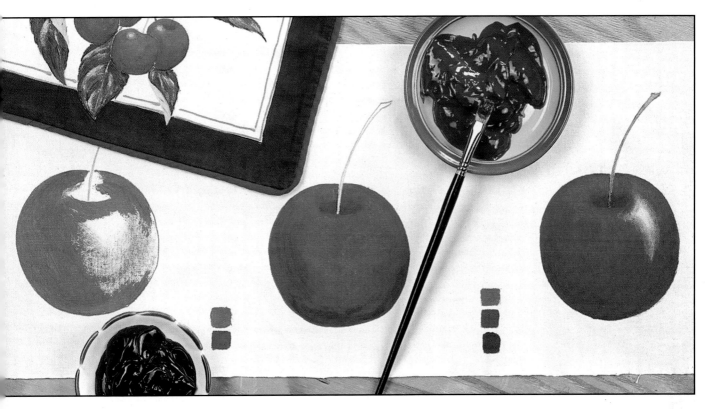

Use the tamping method to distribute the paint evenly and pearl-based colours or white paint for highlights. The design for the place-mat appears at the back of the book.

Dimensions

It is easy to give components of your design a three-dimensional effect by using lighter and darker shades of the same colour.

1. Start by painting the entire component, such as a cherry, in the lightest shade.
2. Now apply a medium shade to the side of the component you want shaded – usually the lower side.
3. Finally use the darkest shade to paint the outer edge of the component.
4. A highlight enhances the appearance of the component. After painting the component, apply a small dot of white paint to the area to be highlighted – usually more or less directly opposite the shaded area.

Hints

- Blend darker and lighter areas into each other; harsh shading spoils the effect.
- If you run out of darker shades, produce them yourself by adding small amounts of navy to the lighter shades. Take care, as navy is an intense colour, so add small amounts at a time.
- Test your ideas on a leftover piece of fabric beforehand.

Sgraffito or scratchwork

Sgraffito is a decoration where parts of the surface (of plaster or clay, for instance) are cut away to expose a different colour underneath. It is used in fabric painting to give texture to certain parts of the design, such as the veins of leaves, or borders.

Use dark shades to emphasise the sgraffito effect. Experiment with dark red, dark green, dark blue and dark brown, or any other darker hues. Make the scratch patterns with any sharp tool such as a kebab stick, table fork, Afro-comb or the back of a paintbrush, depending on how fine or coarse you want the lines to be.

Plan ahead when applying the paint and work on small areas at a time, otherwise the paint may dry in patches. Apply the paint liberally to ensure effective contrast and spread it evenly over the area using a wide paintbrush. Scratch the design in the wet paint, constantly cleaning the tip of the tool to prevent blotches.

To gain confidence, it would be best to first practise scratching the design on a piece of leftover fabric.

Mistakes can be corrected provided this is done immediately. The entire design must be smoothed with a paintbrush before you start again. It is not, however, always possible to remove your scratch marks, so rather practise before you start!

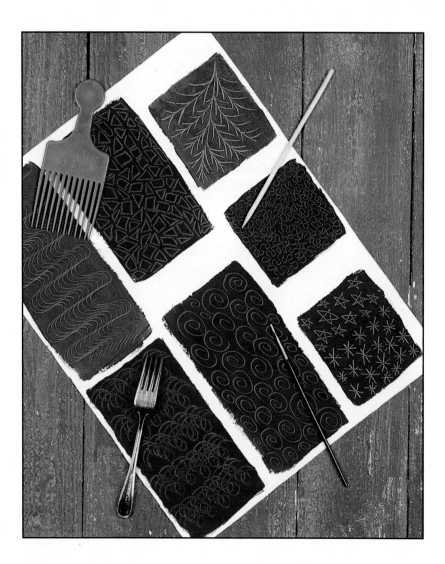

The sgraffito technique provides endless possibilities, and a vast range of tools can be used to obtain exciting effects. Always make sure that the paint is wet when you do scratchwork on fabric.

Use the wet-on-wet technique when you want to paint your own design and would like to obtain a soft, hazy effect.

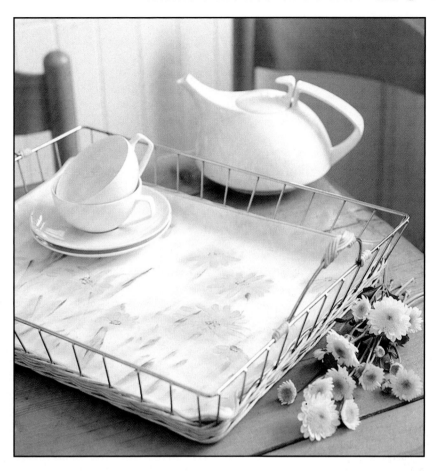

Wet-on-wet technique

With this technique the colours flow and merge to create a hazy effect as opposed to being crisp and sharp, as is usually the case in fabric painting.

1. First, cover the work surface with a waterproof covering for protection.
2. Wet the fabric, smooth it over the working area and lightly paint in the background colours, allowing them to blend into each other.
3. The designs are not drawn beforehand, but are painted directly onto the background with bold strokes of the paintbrush.
4. Keep a spray bottle on hand to moisten the fabric if it dries during the painting process.
5. Coarse table salt, sprinkled on the back- ground paint while still wet, creates an interesting mottled effect. Do not remove the salt until the fabric is completely dry.
6. Once the paintwork has been completed, leave the cloth in position on the work surface to dry slowly.

Hints

- By combining the wet-on-wet technique (background) with ordinary dry-cloth techniques (motifs) you can create beautifully crisp designs with soft, hazy backgrounds.
- Bear in mind that the background will cover the entire area, therefore use light shades, otherwise the background may interfere with the design. If the back- ground is too dark, use opaque paints for the motifs.

Designs and motifs

Since many beginners have difficulty in selecting or creating their own designs and motifs, I have included over 100 designs that can be used for fabric painting. Different people like different things and I have therefore tried to cater for as wide a variety of tastes as possible. Hopefully you will find a few designs and motifs that appeal to you!

Designs may be traced and photocopied, and also enlarged and adapted. Be adventurous – add your own touch to make them completely individual.

Enlarging and reducing designs and motifs

It is best to use a sophisticated photocopier (usually available at instant printing or speciality shops) because this enables you to enlarge and reduce by various percentages. However, if a photocopier is not available to you, the graph method works just as well.

Draw parallel vertical and horizontal lines over the design that you want to enlarge or reduce. In this way a number of squares are formed. Cut a piece of paper the same size as the design you have in mind and draw the same number of horizontal and vertical lines onto it. You have now divided it into the same number of squares as the original design.

Number the squares of the original and the new design along all four sides. Now draw the lines in each square of the original design onto the corresponding square of the new design. The squares of the new design will be larger if the design is being enlarged, and smaller if it is being reduced.

The graph method can also be used to change the proportion of a design. Change a square design to one that is long and thin by drawing a graph with the same number of squares as the original design, but with vertical rectangles instead of squares. Use horizontal rectangles if you require a wider design.

Note: Photocopying a design or motif is permissible. Note, however, that it is an infringement of the Copyright Act to make photocopies of printed material for distribution purposes.

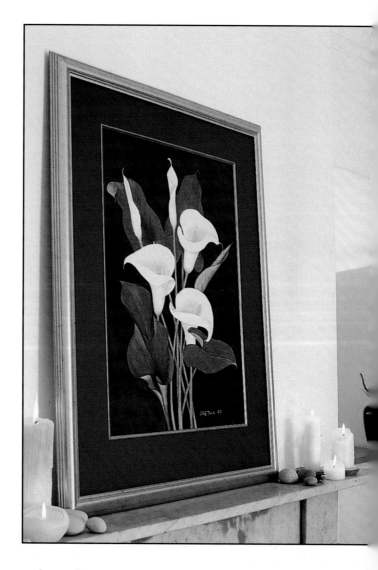

Kraft stencilling (see page 19) was used to create this bold and dramatic picture. Contrasting colours were chosen for a more striking effect and the sgraffito technique (page 28) can be seen on the leaves – in this instance a kebab stick was used.

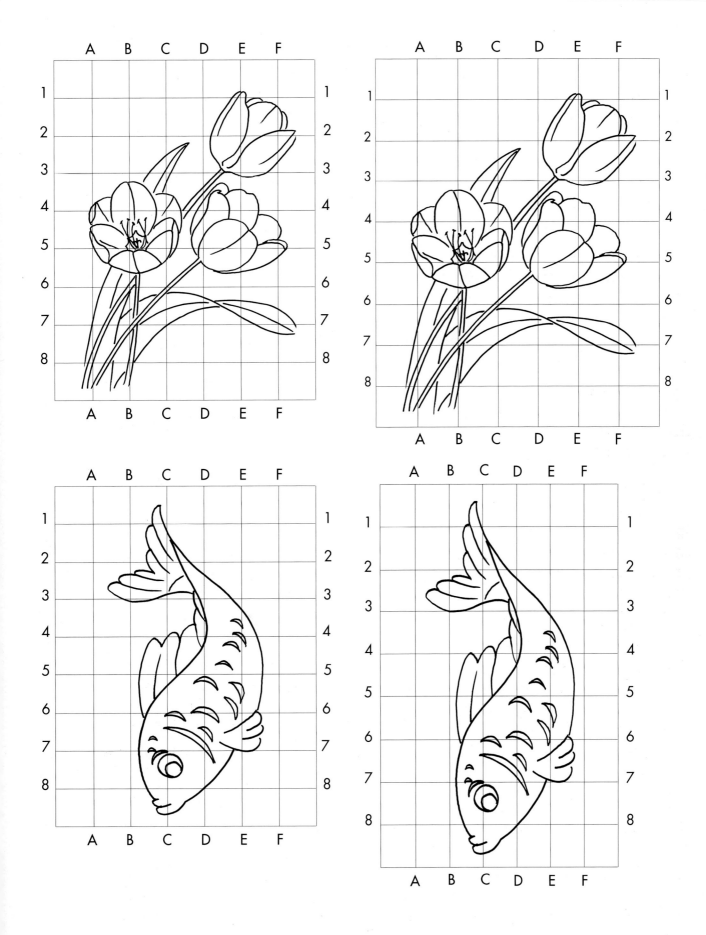

Designs and motifs

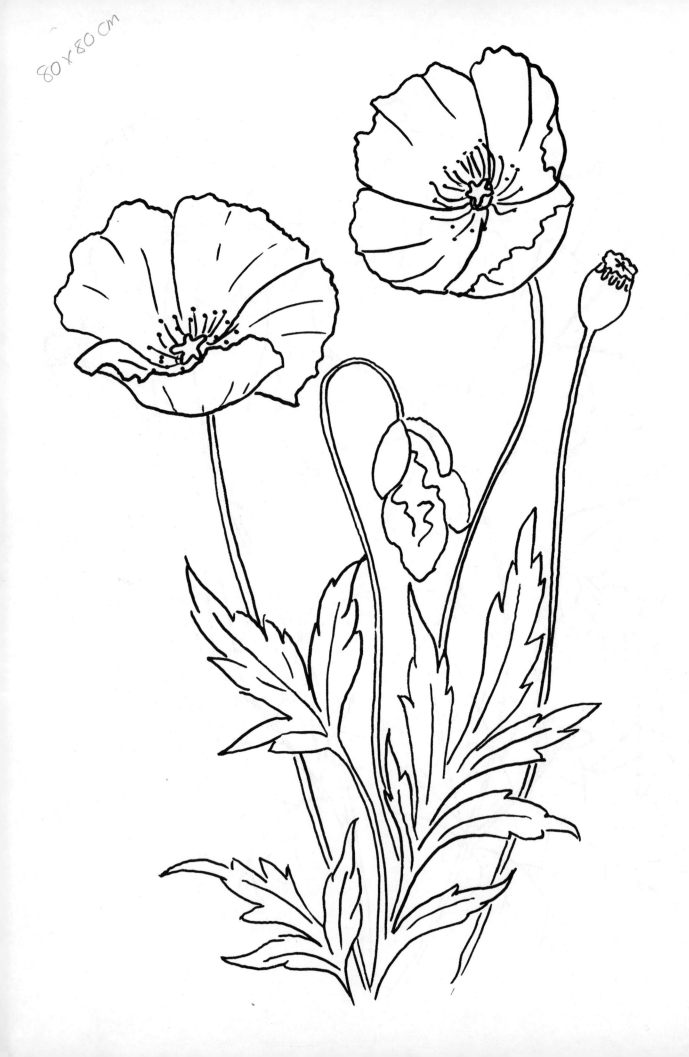

80 x 80 cm

80 x 80 cm

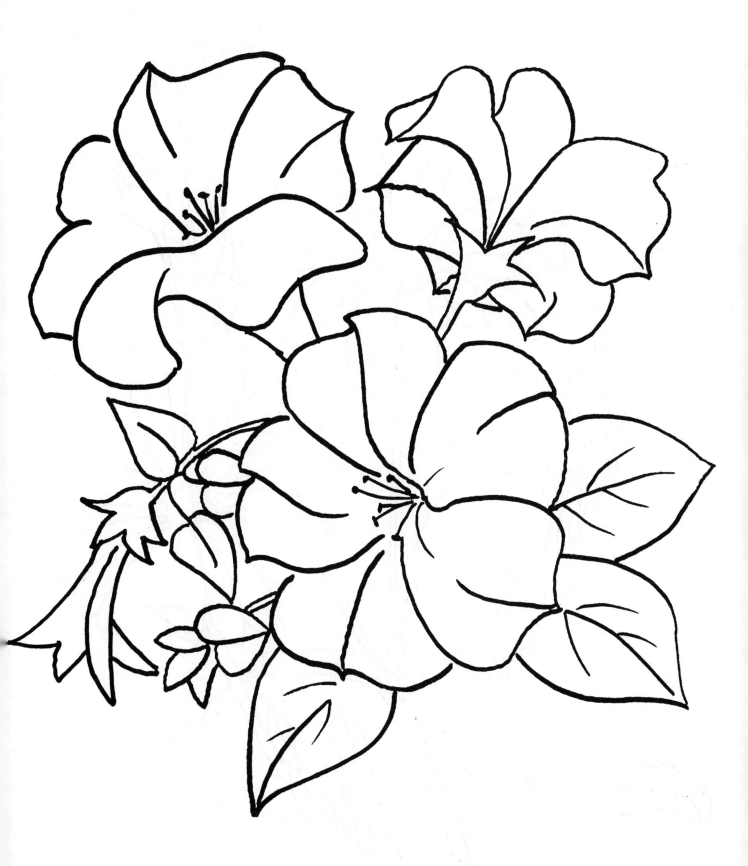

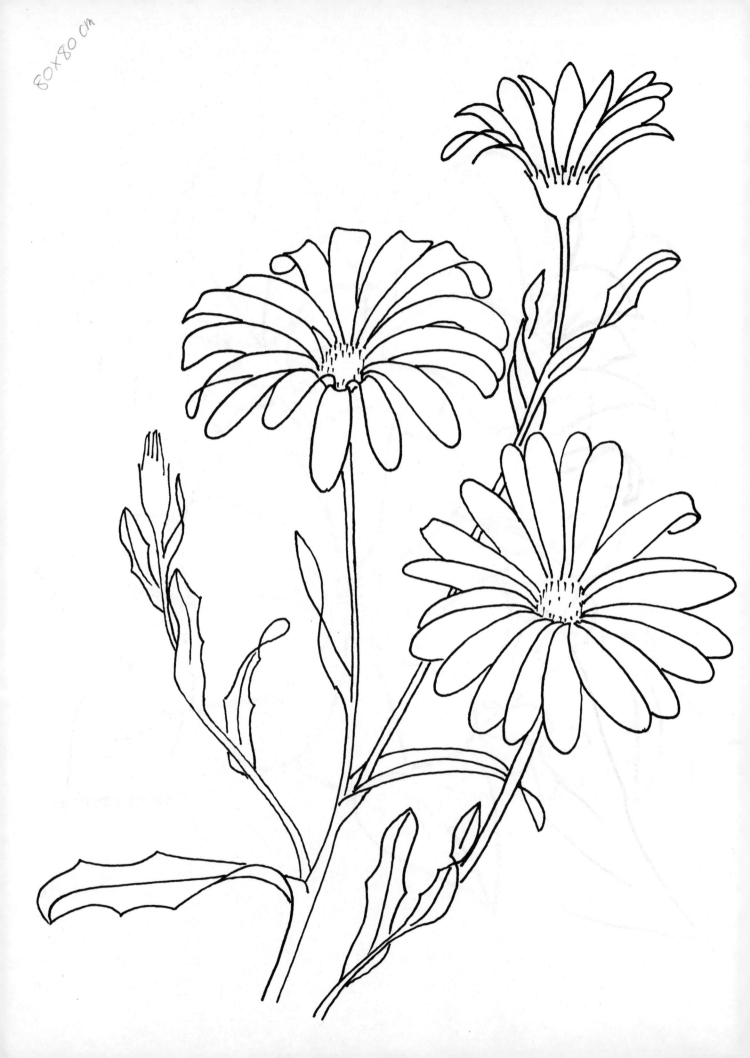

80x80 cm

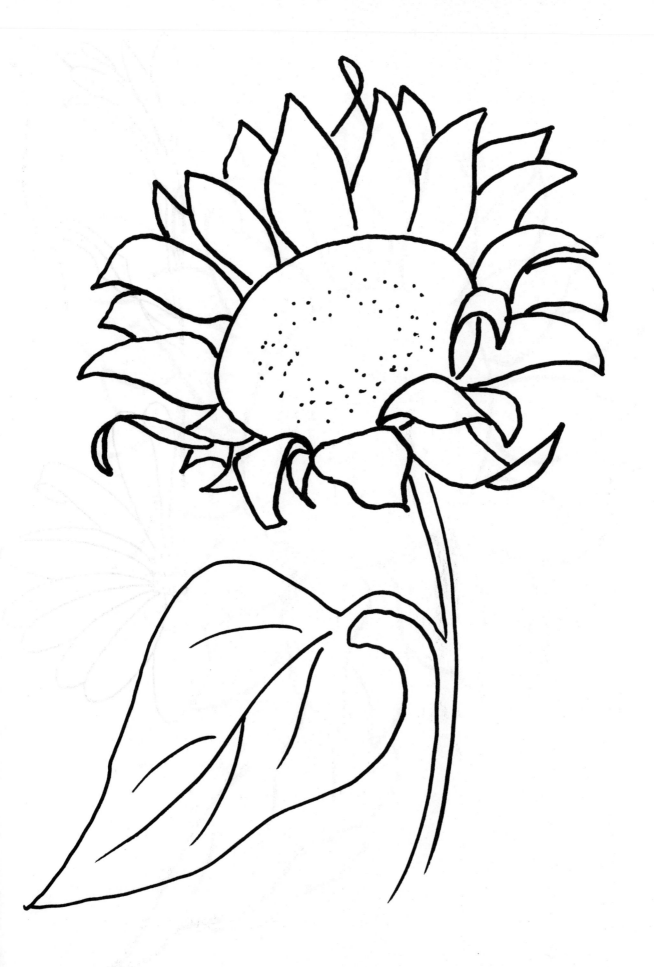

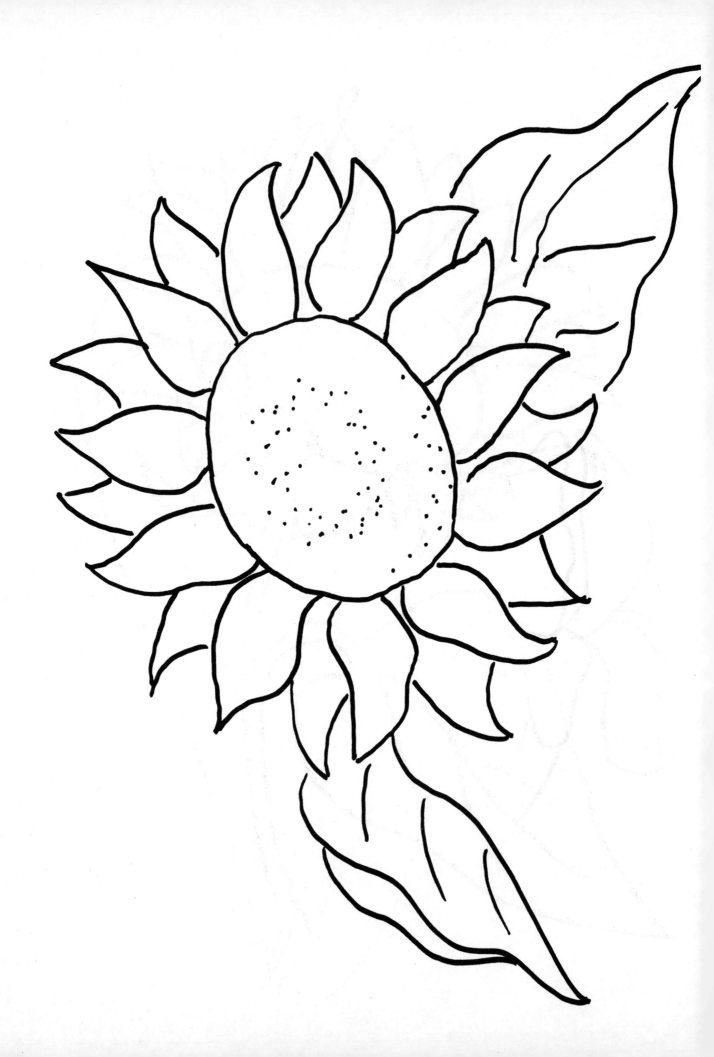

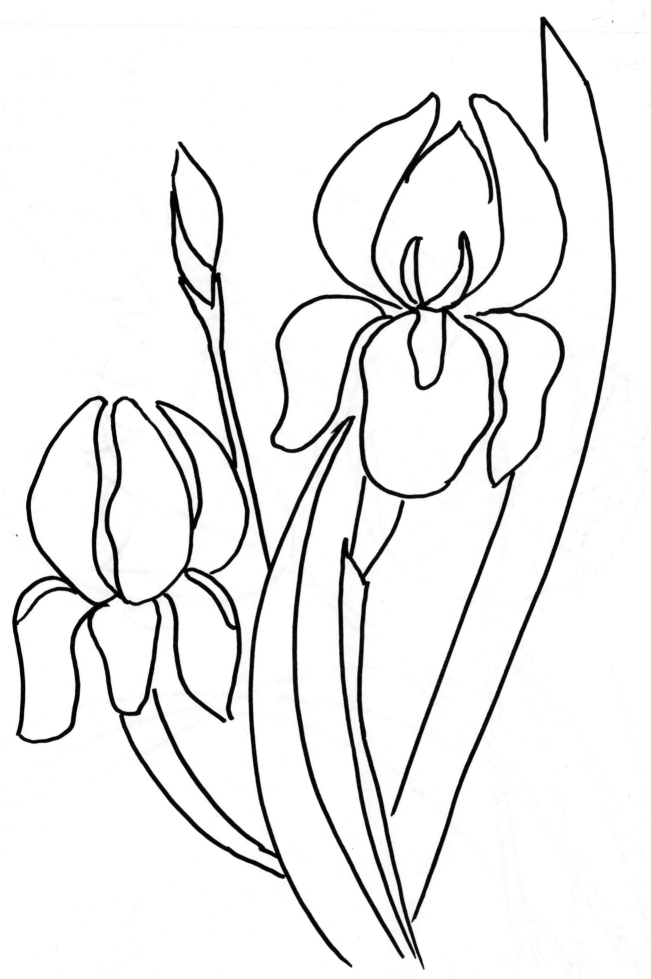

80X80cm

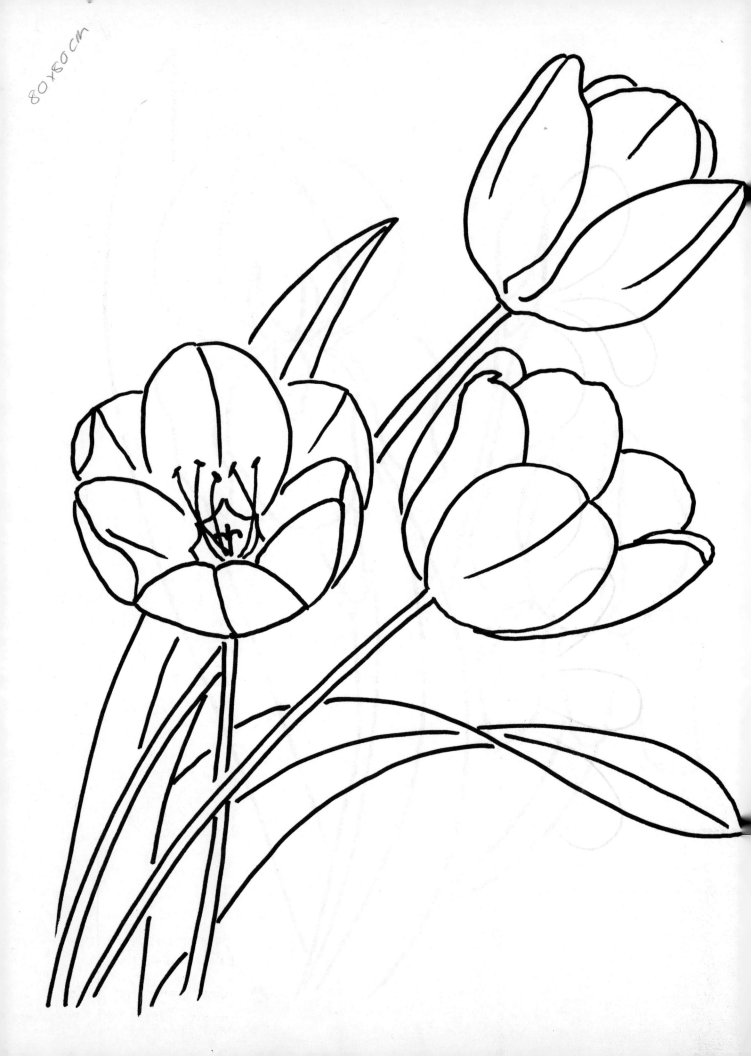

80x80 cm

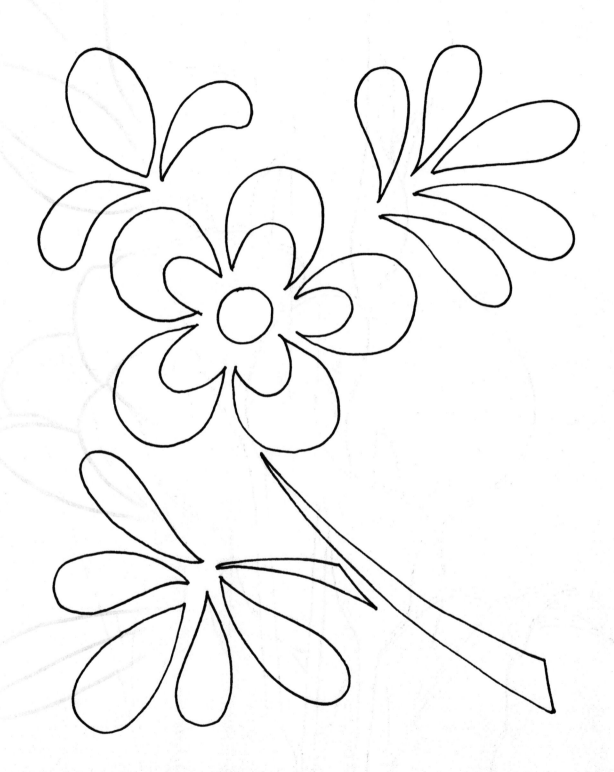

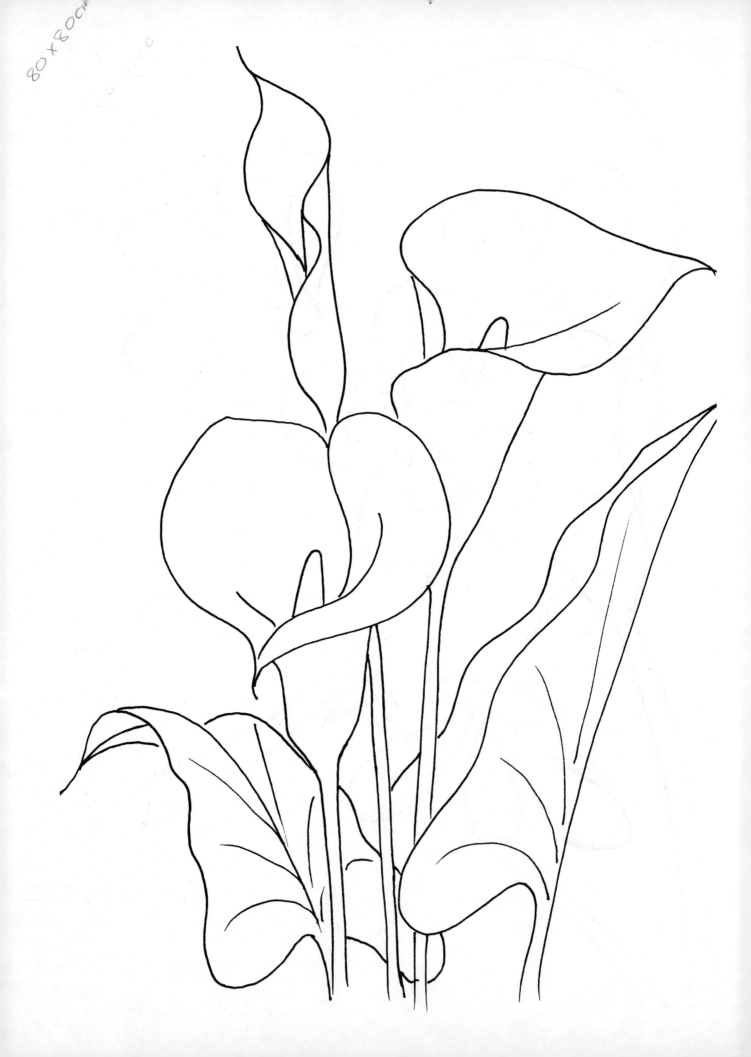

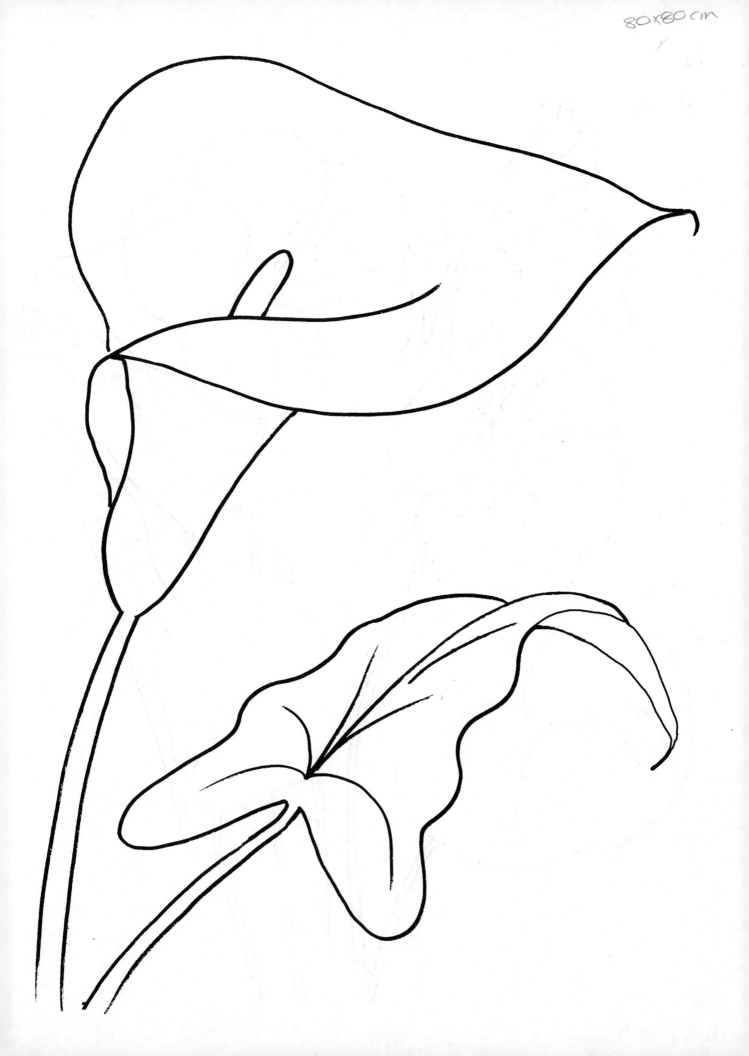

80x80 cm

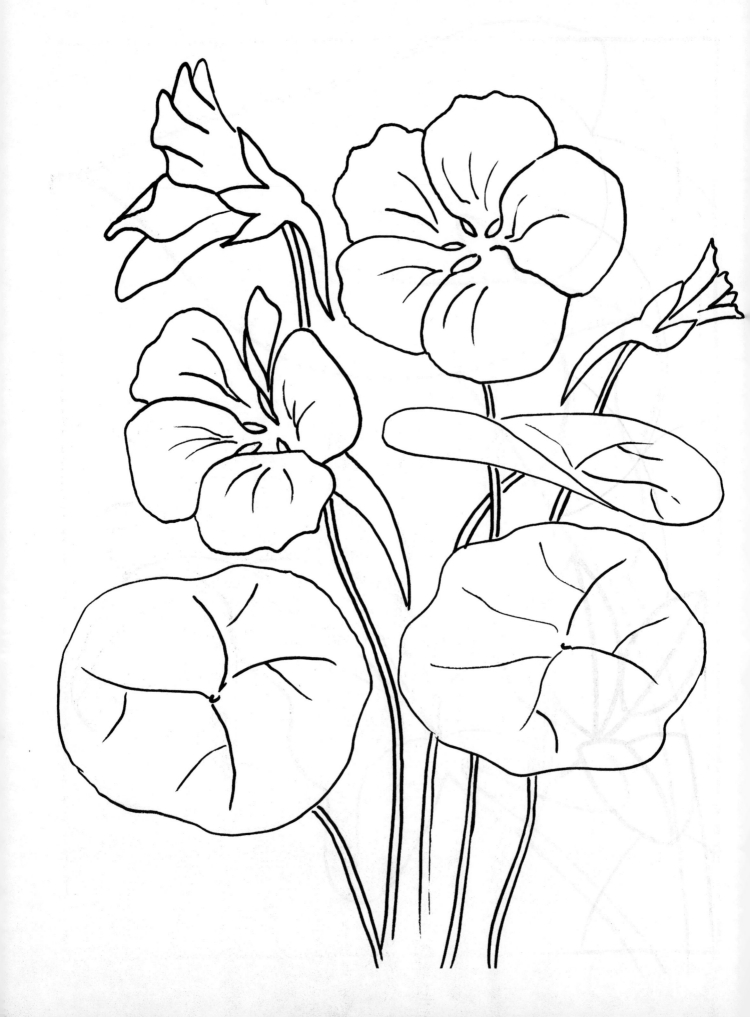

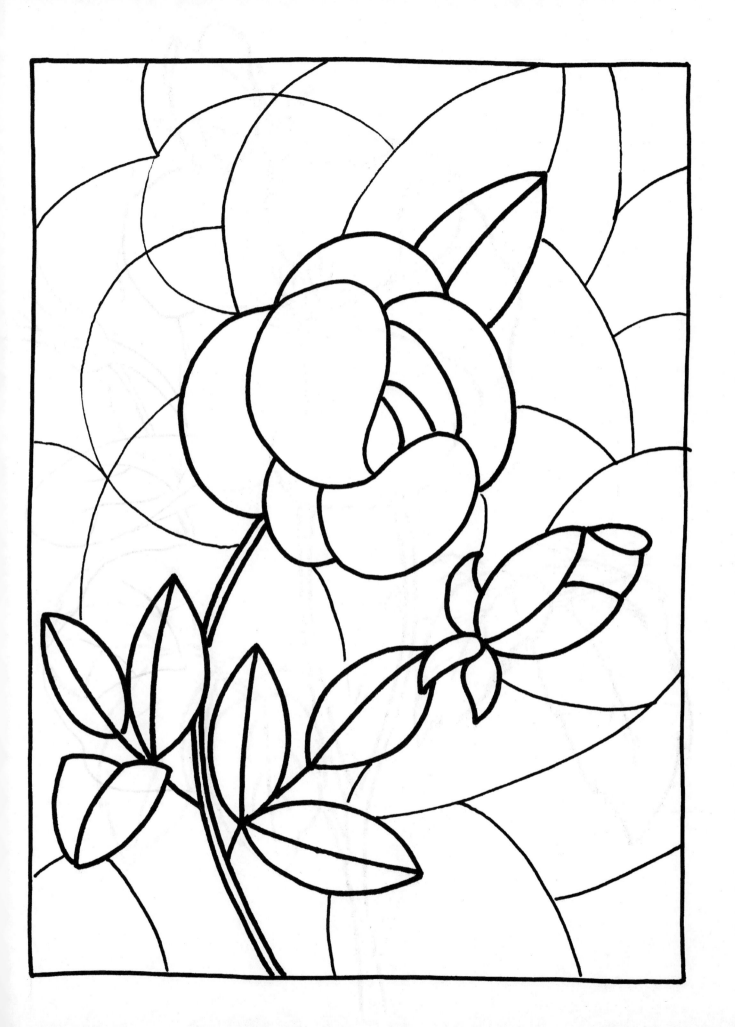

80 x 80 cm

80x80

89×80

80 x80

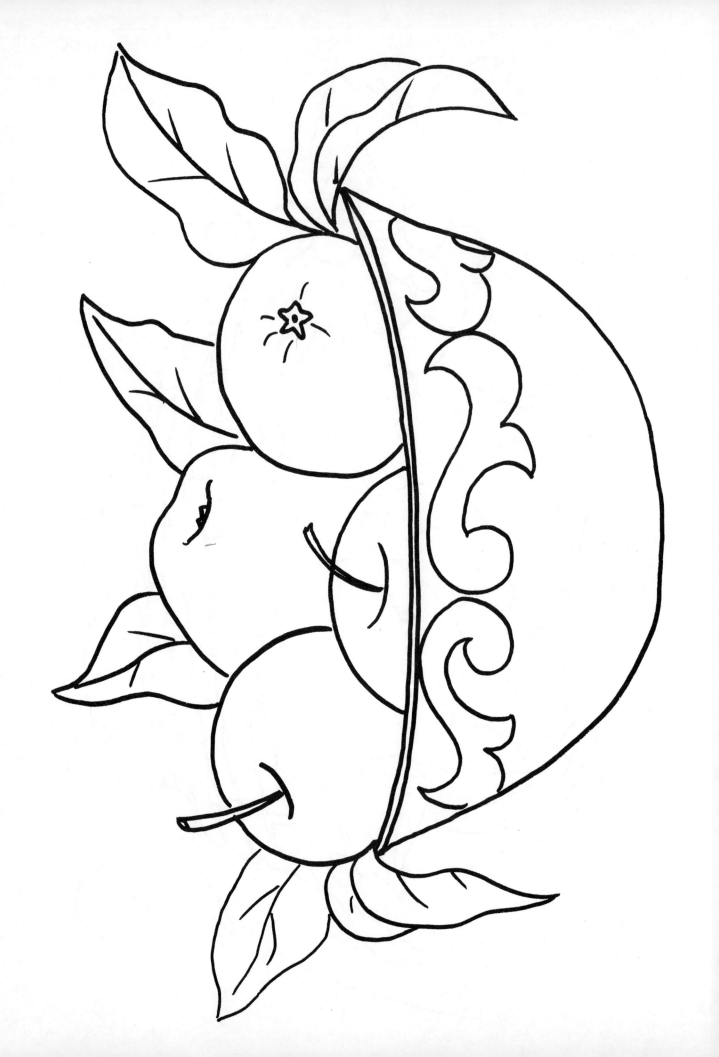

80×80
+ 60×60

80 x 80
+ 40 x 40

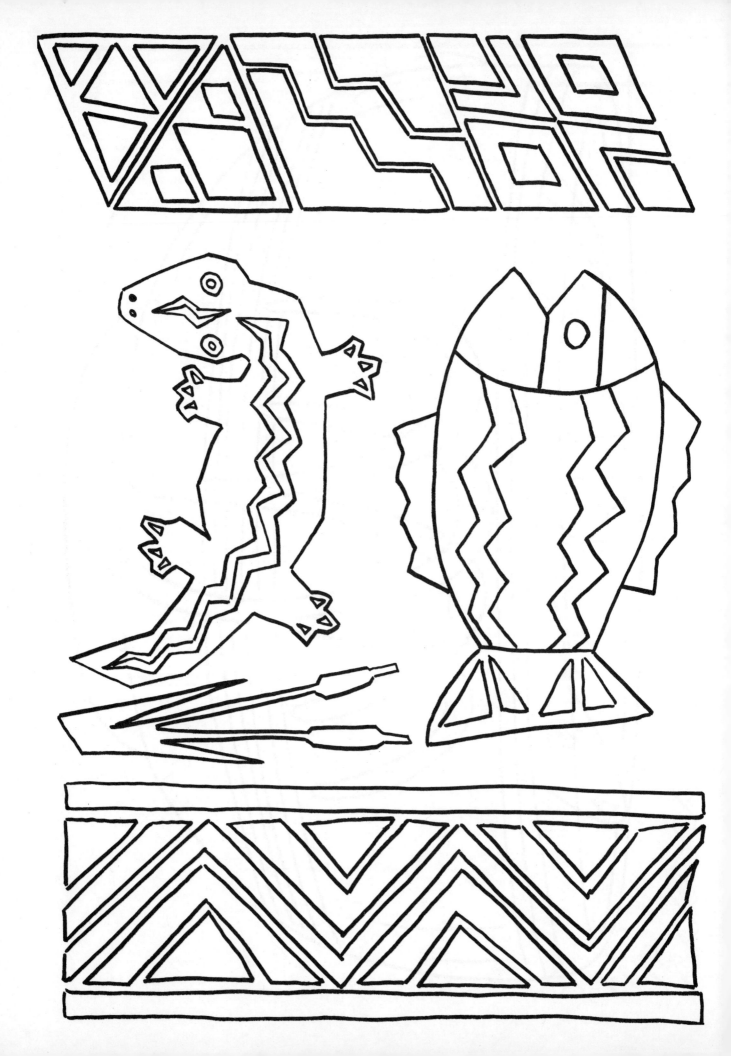

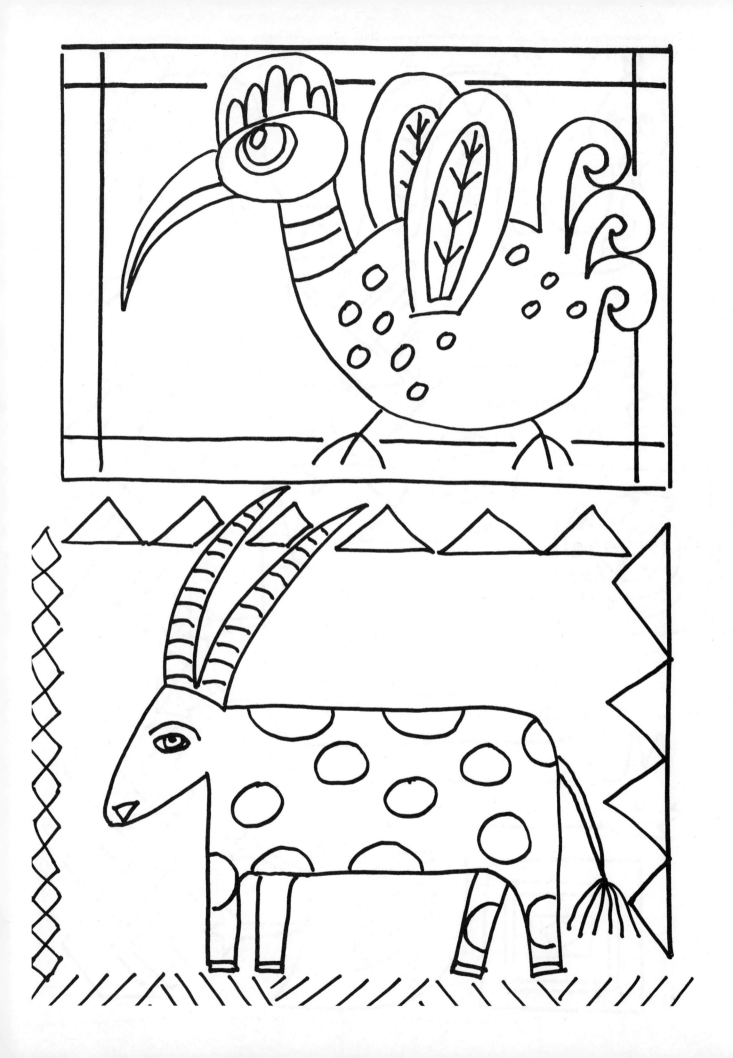

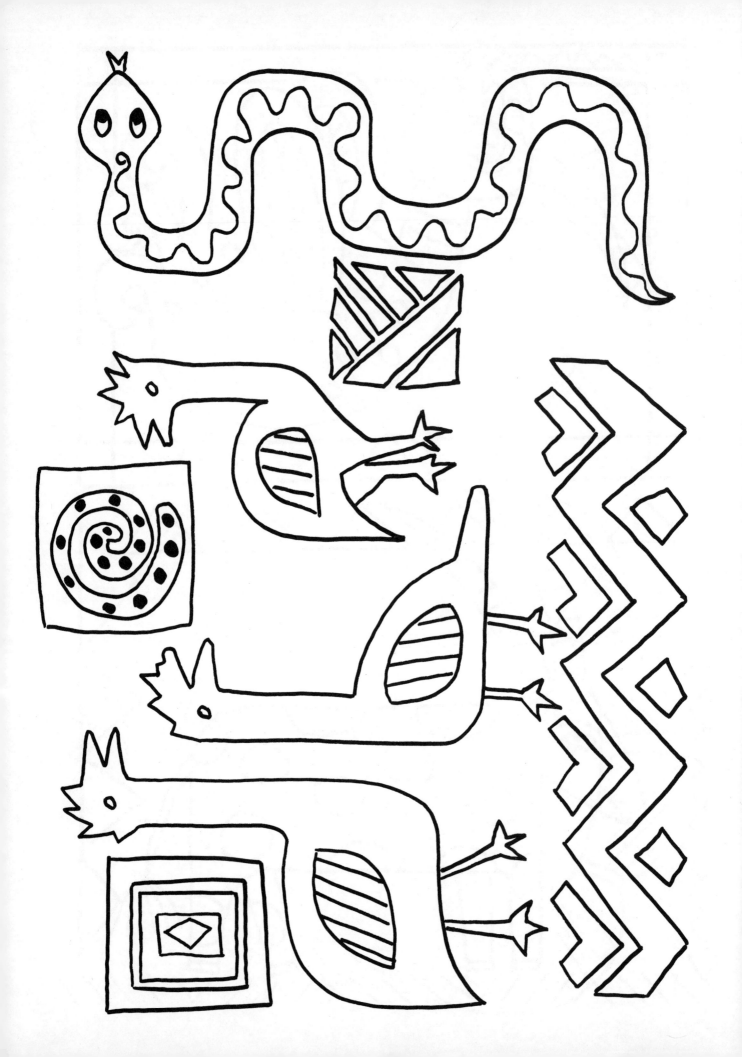

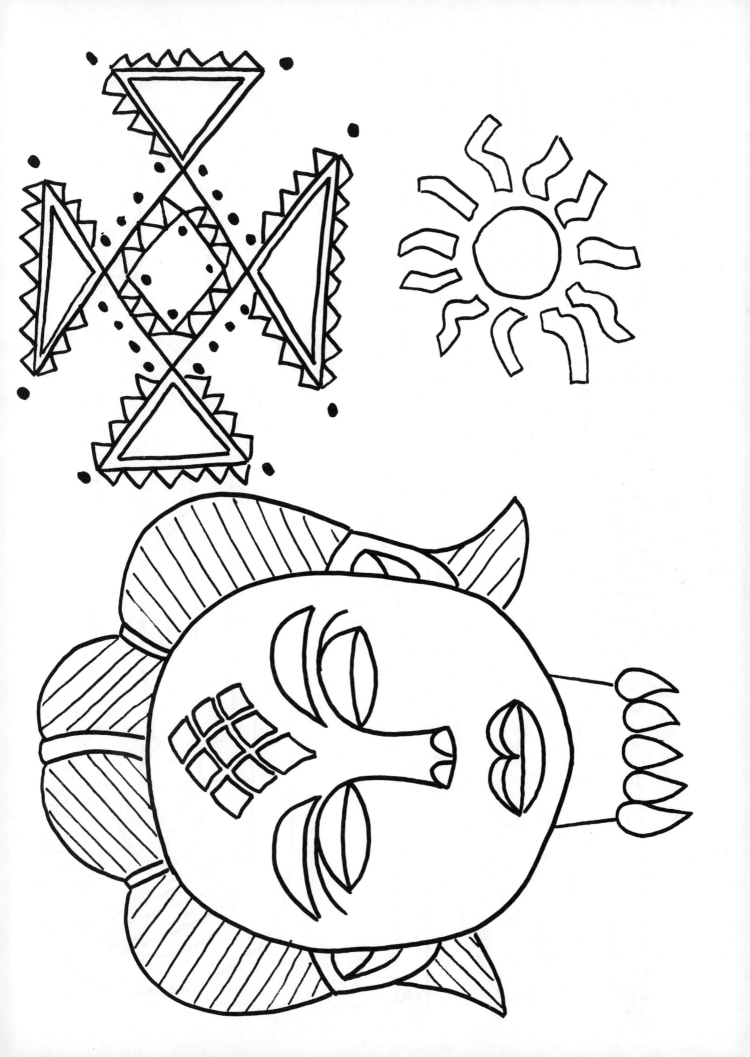

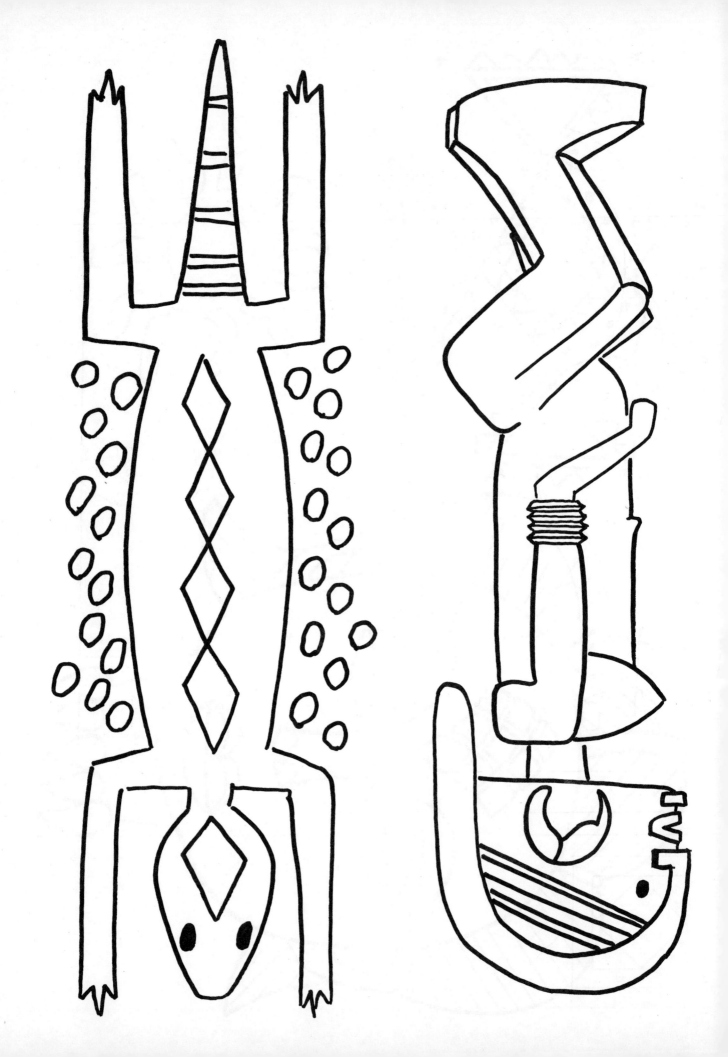

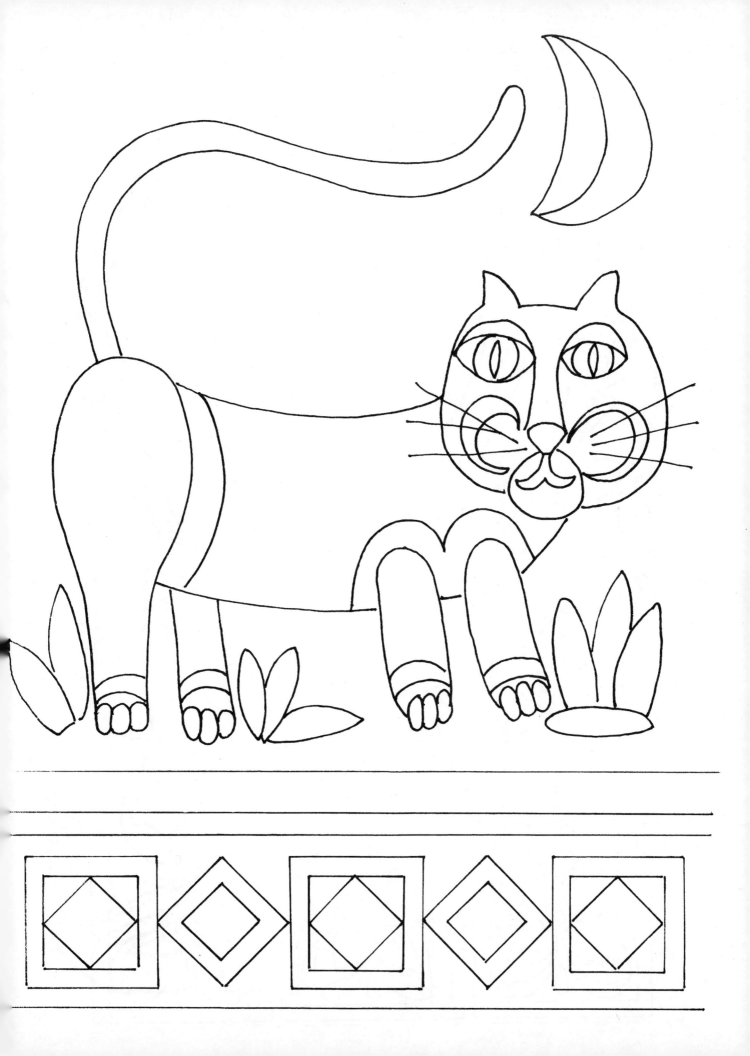

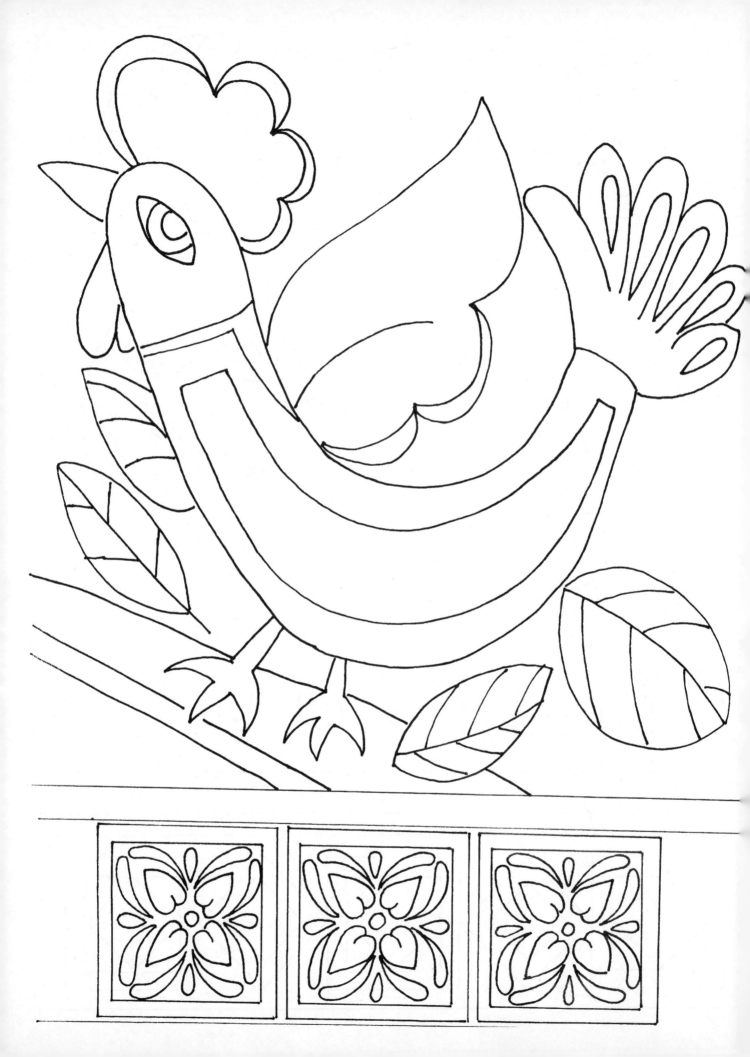

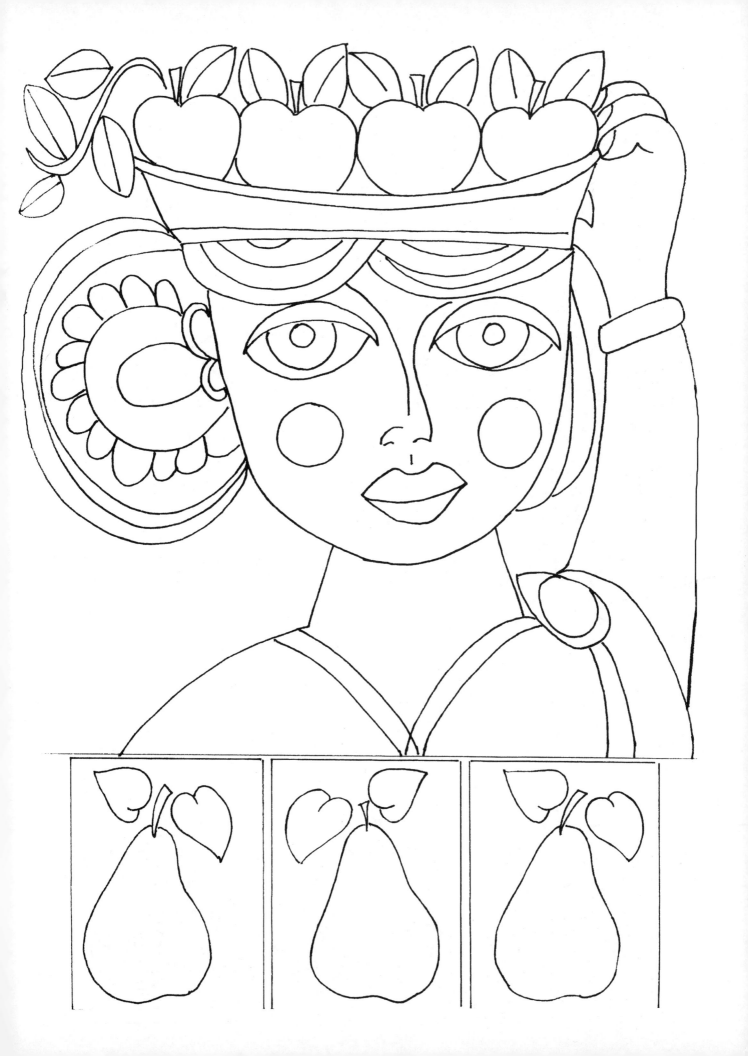

CHRISTMAS

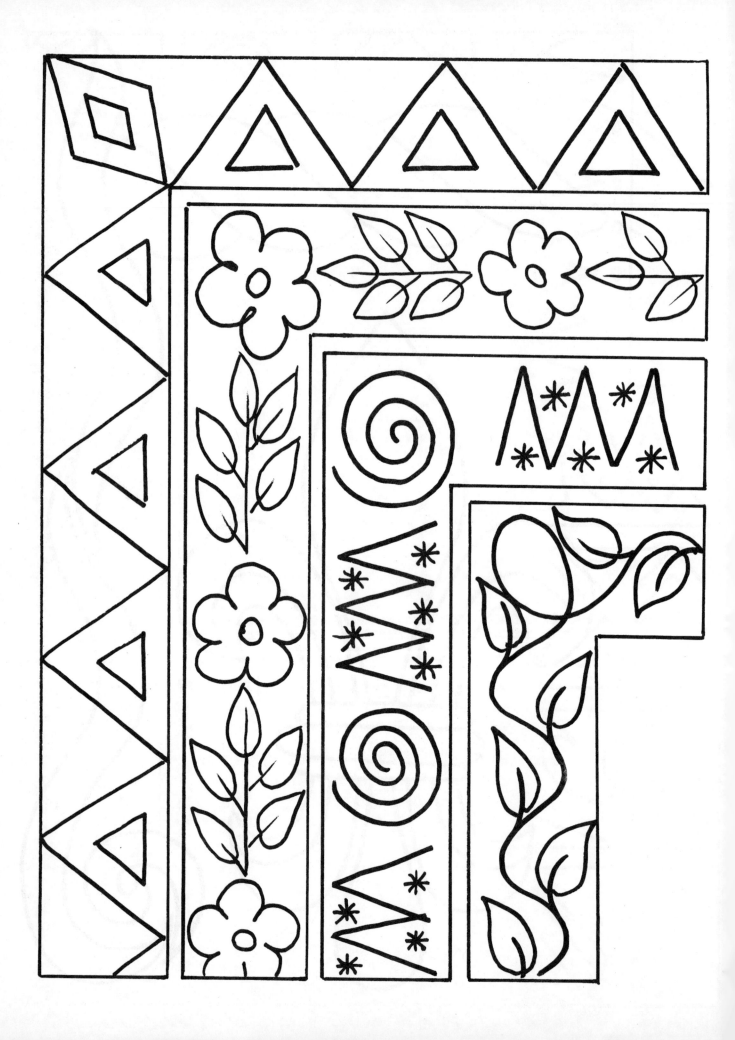

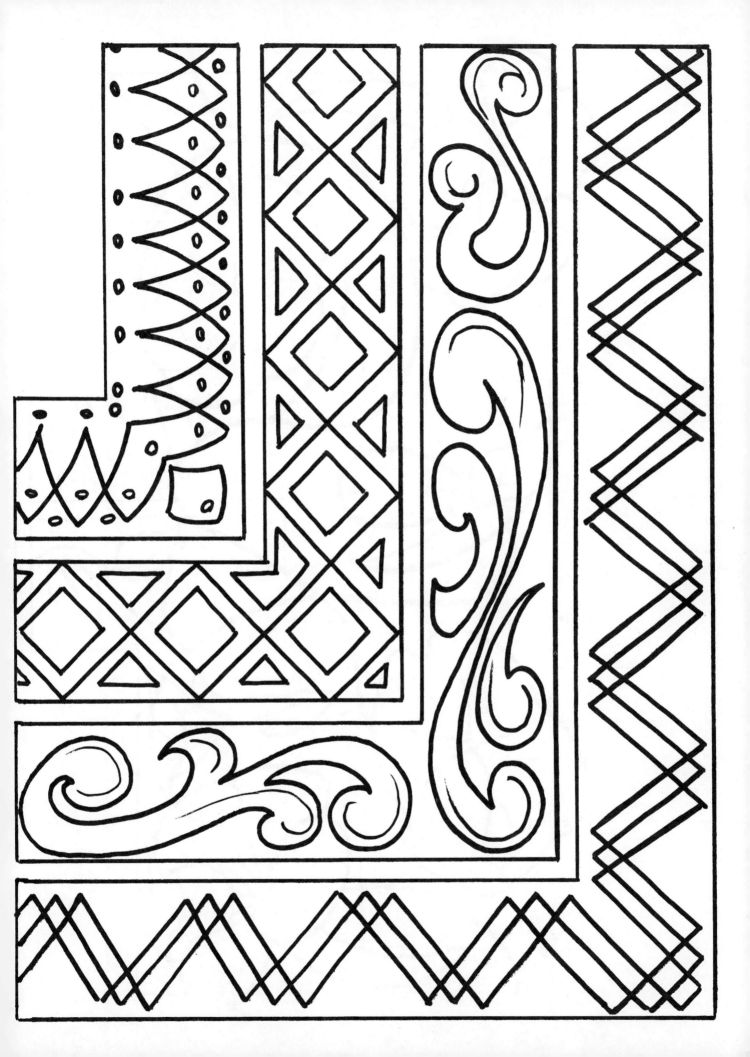

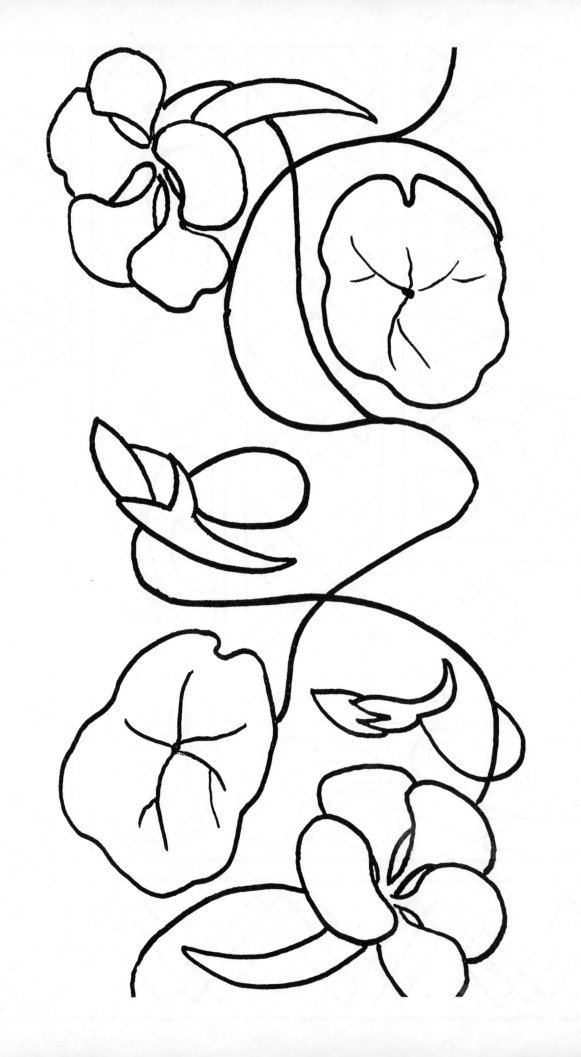

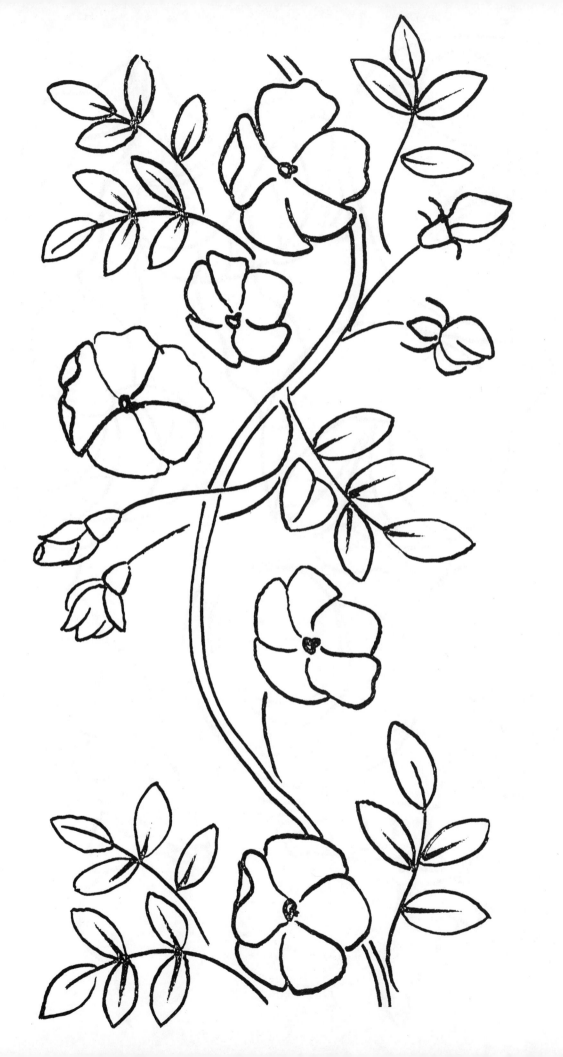

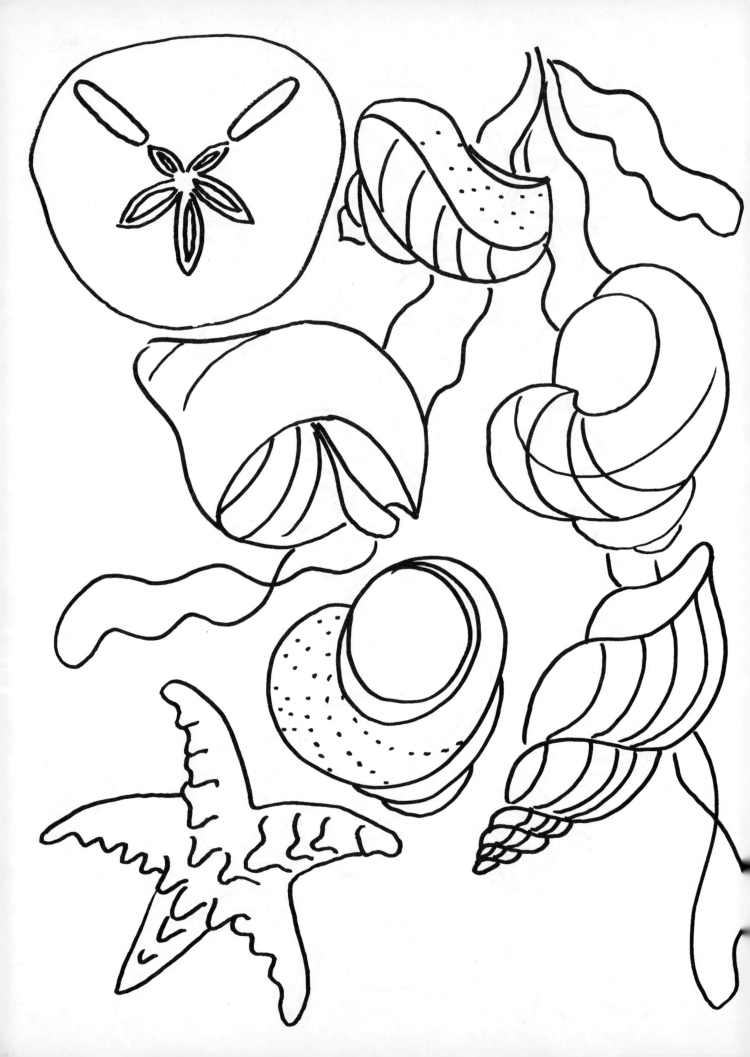

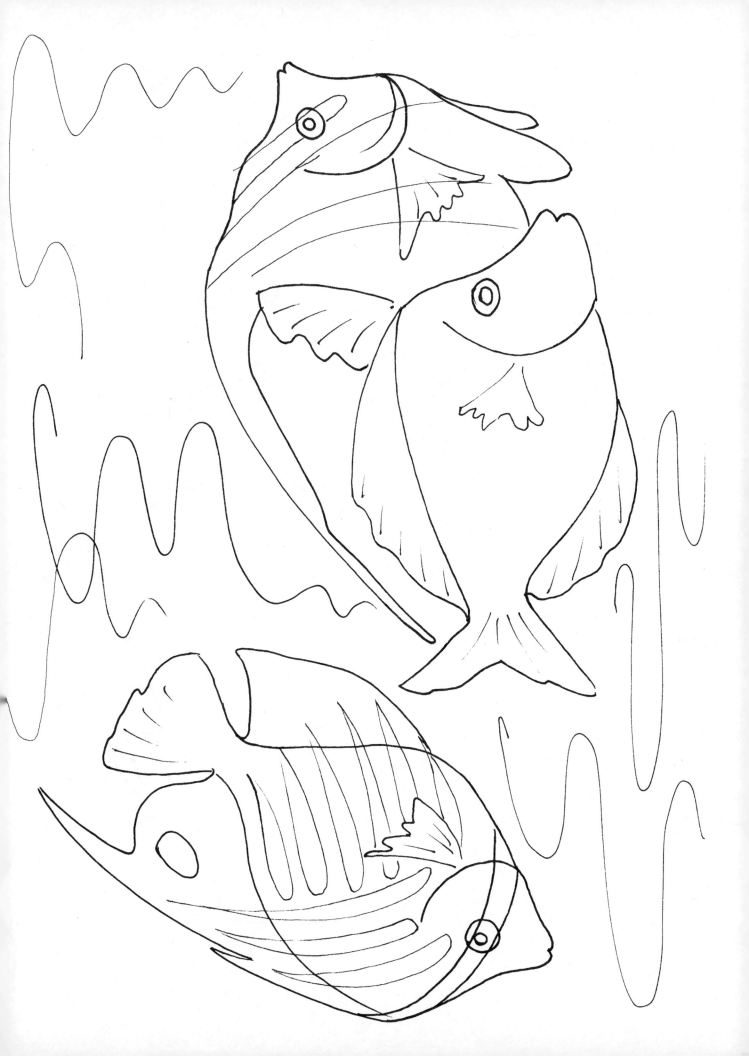

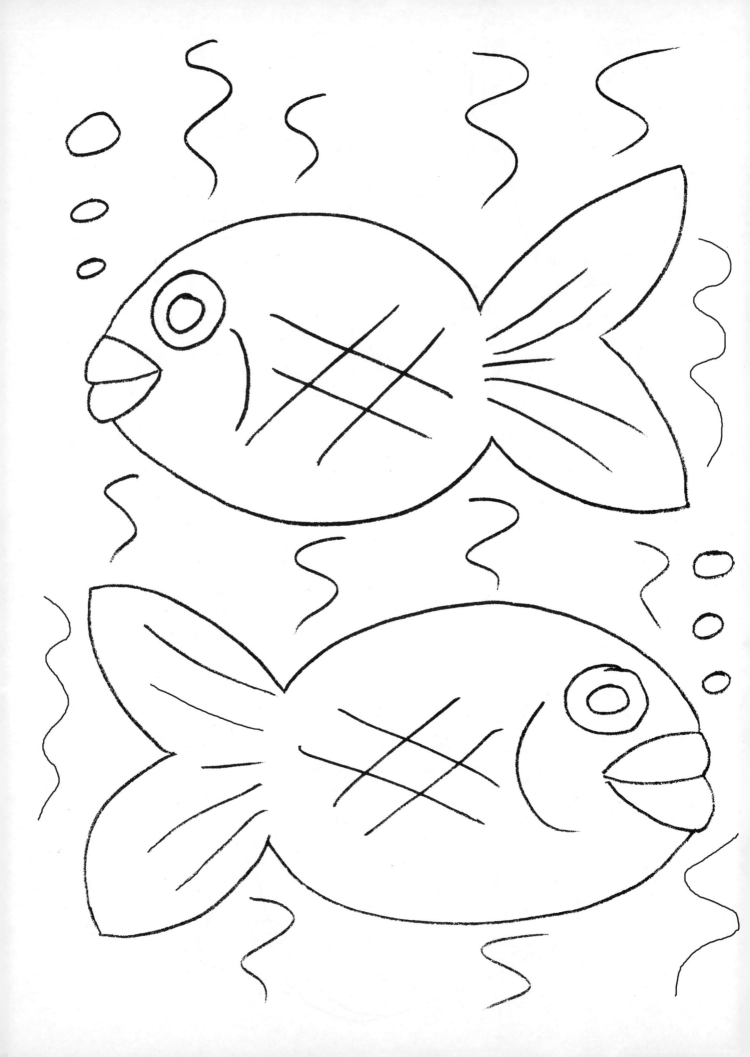

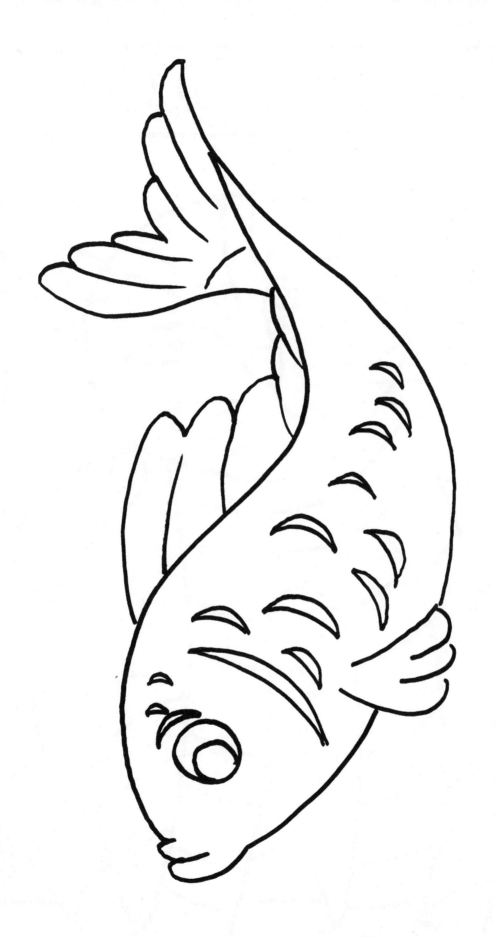

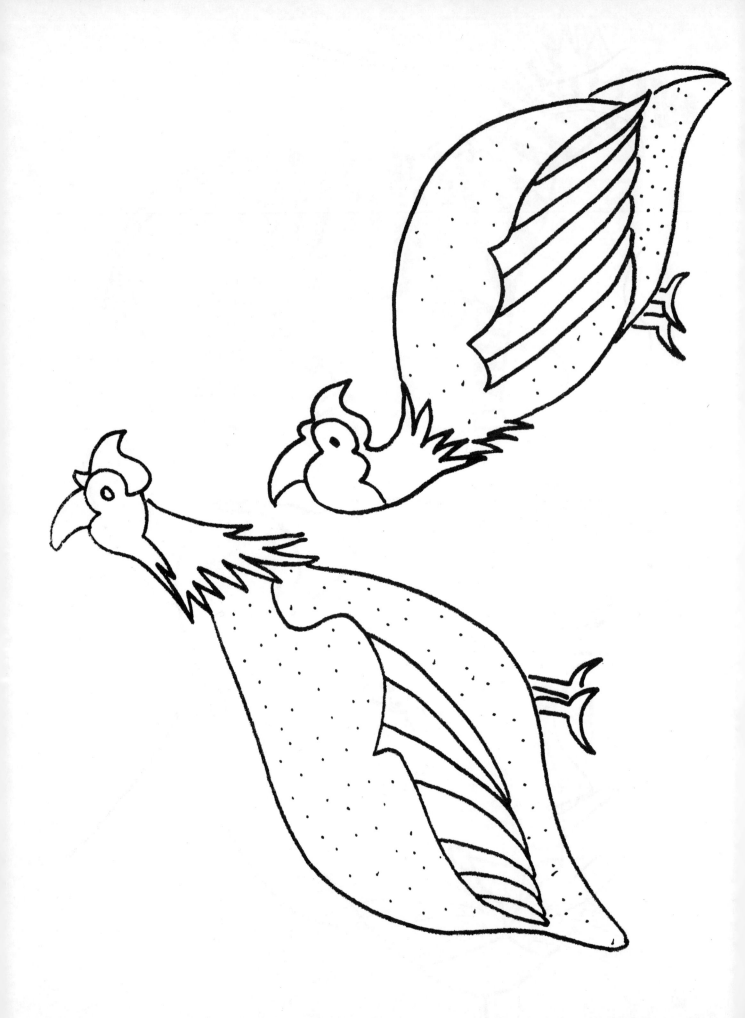

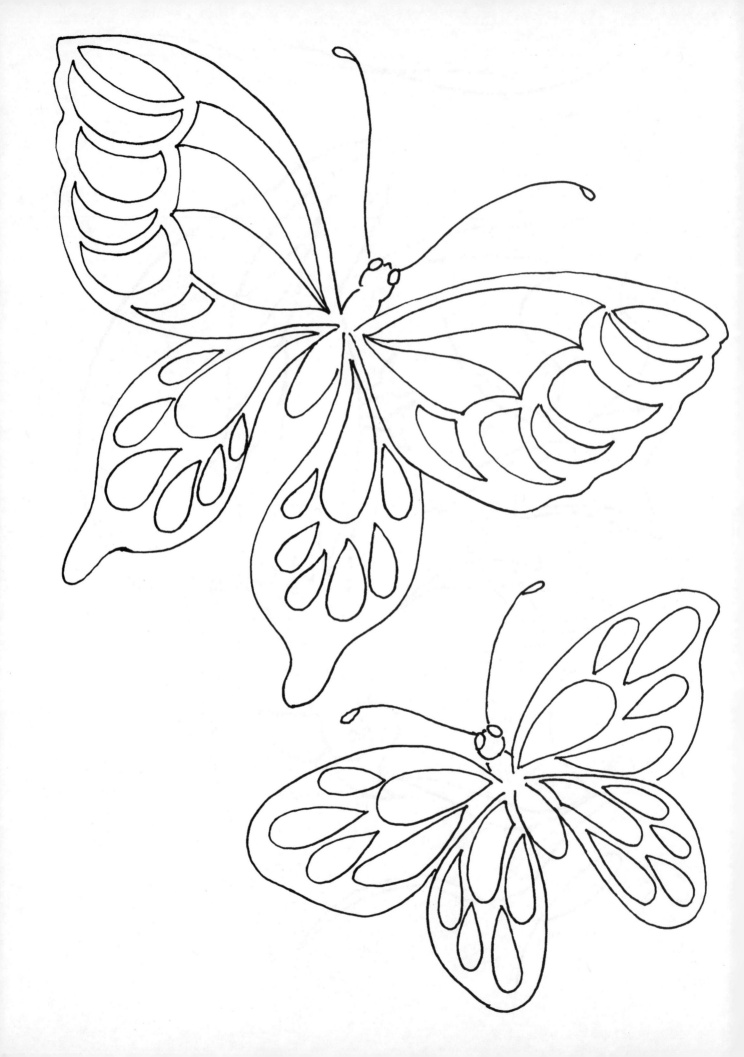

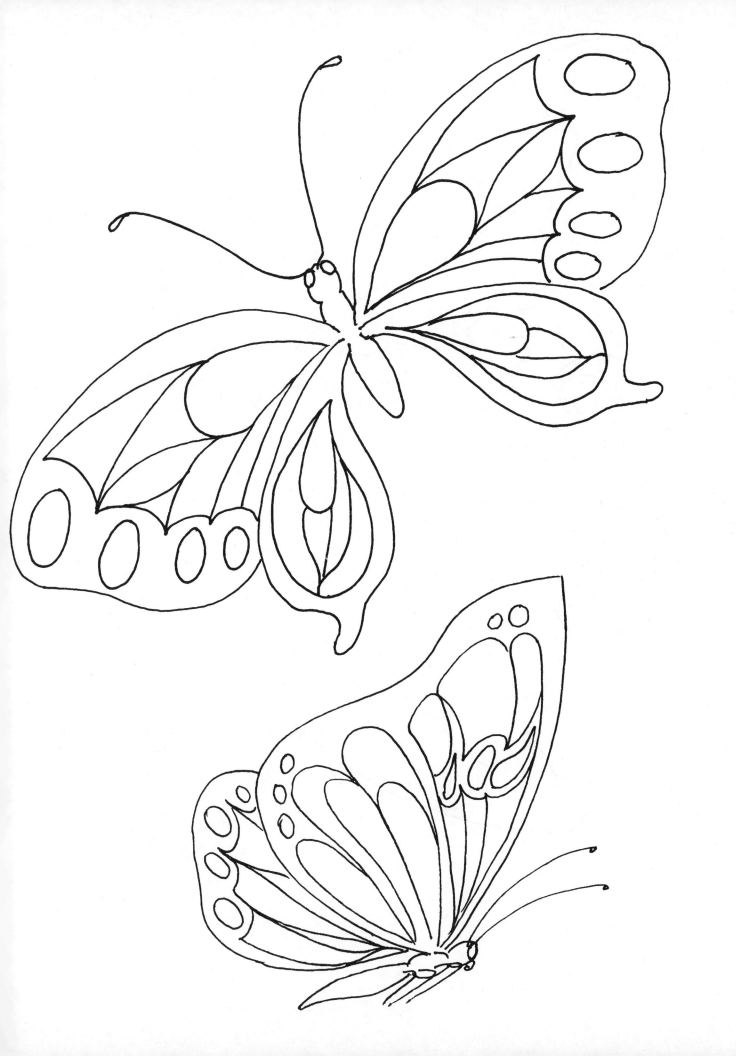

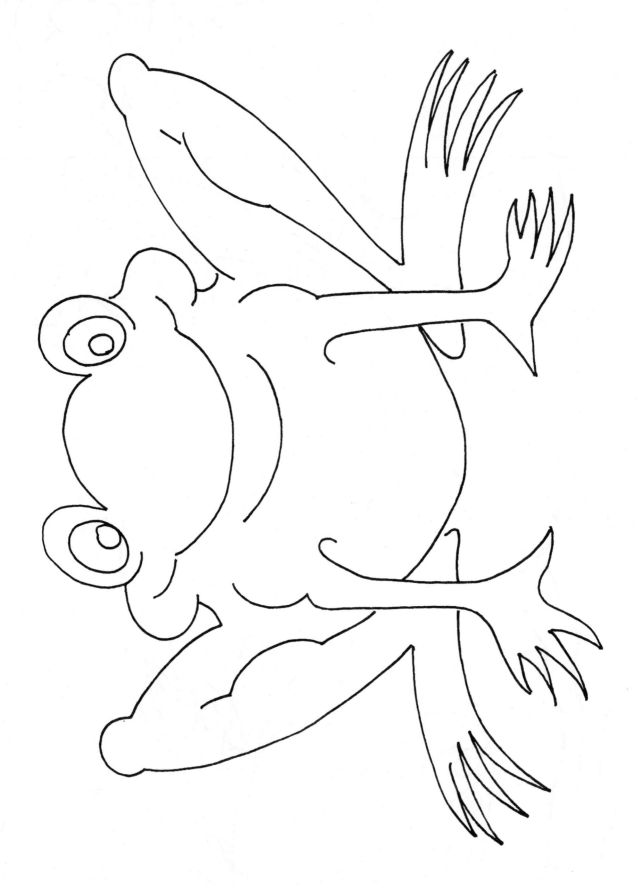

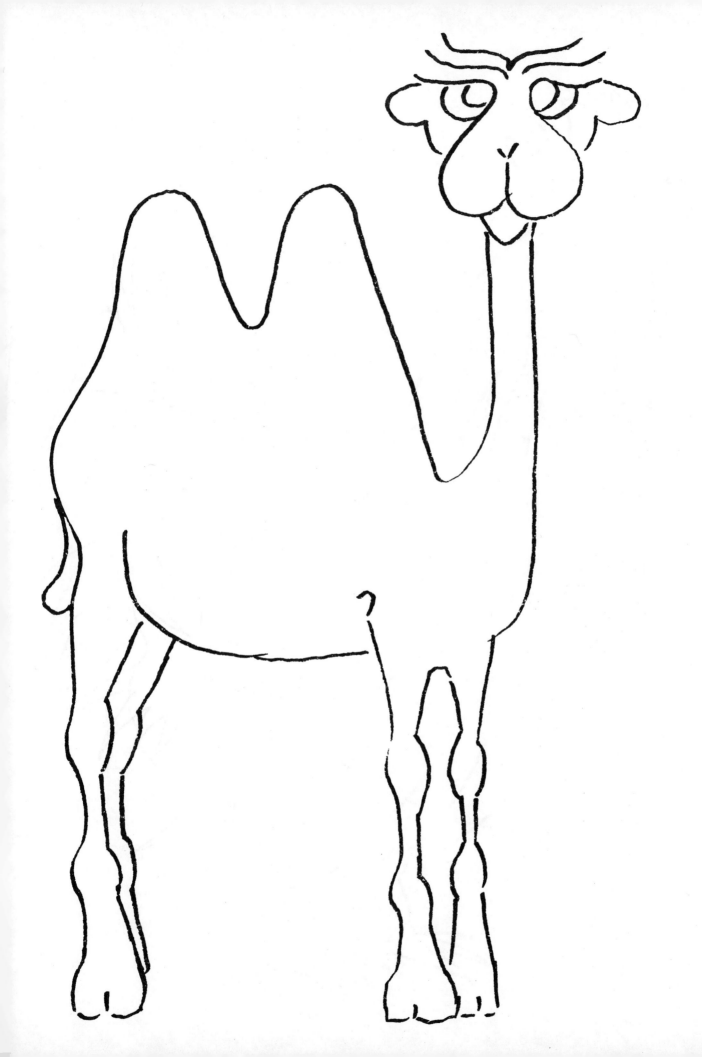

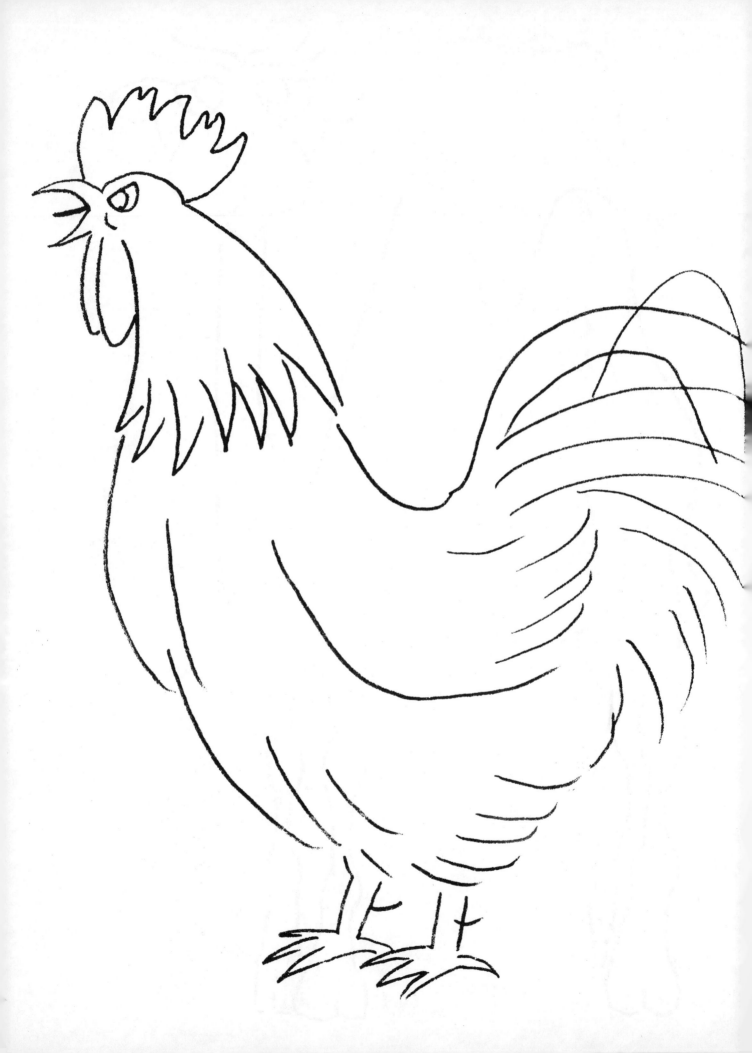

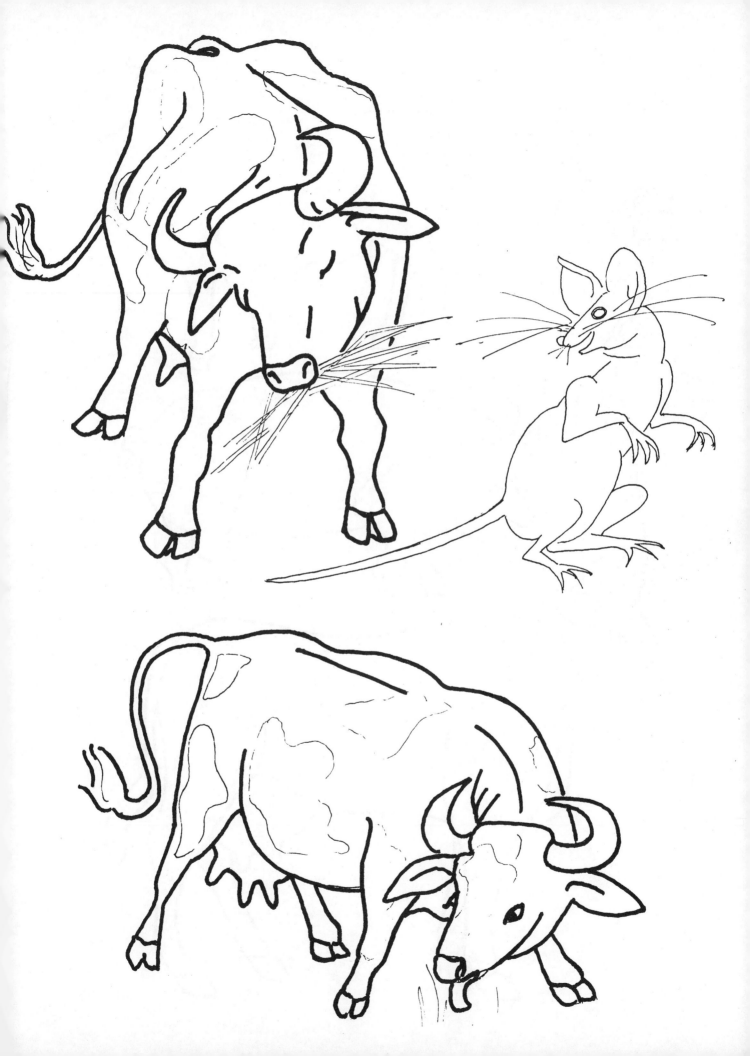

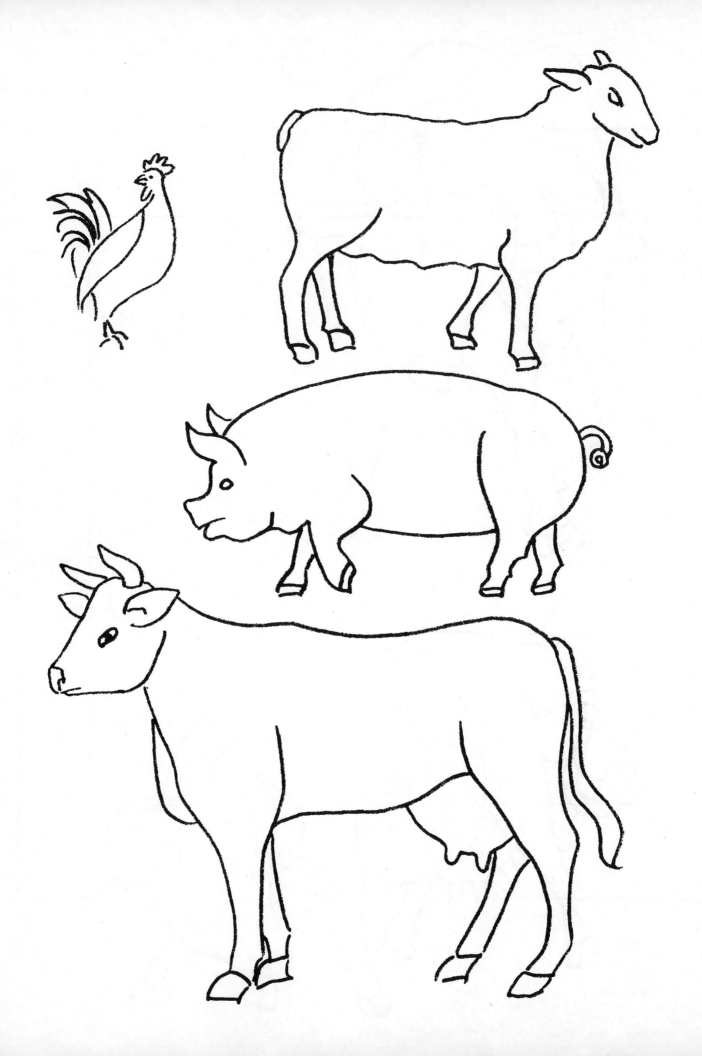

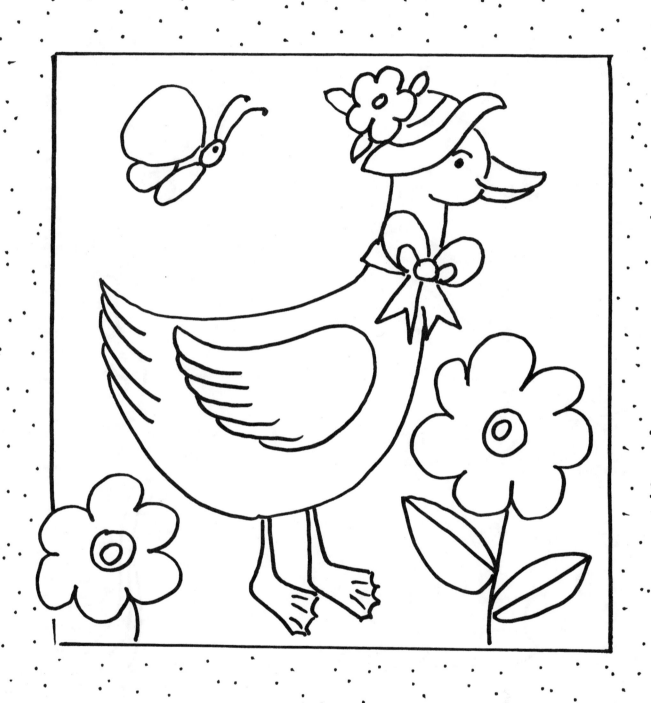